iN PuRSuit OF iNSPiRatioN

iN PuRSuit OF iNSPiRatioN

TRUST YOUR INSTINCTS aNd
MAKE MORE ART

raE duNN

CHRONICLE BOOKS

SAN FRANCISCO

Library of Congress Cataloging-in-Publication Data

Names: Dunn, Rae, author.
Title: In pursuit of inspiration : trust your instincts and make more art /
 by Rae Dunn.
Description: San Francisco : Chronicle Books, [2019]
Identifiers: LCCN 2018031542 | ISBN 9781452168852 (alk. paper)
Subjects: LCSH: Drawing—Problems, exercises.
Classification: LCC NC735 .D86 2019 | DDC 741.2—dc23
LC record available at https://lccn.loc.gov/2018031542

ISBN: 978-1-4521-6885-2

Manufactured in China.

10 9 8 7 6 5 4 3 2 1

Chronicle books and gifts are available at special quantity discounts to corporations,
professional associations, literacy programs, and other organizations. For details and
discount information, please contact our premiums department at corporatesales@
chroniclebooks.com or at 1-800-759-0190.

Chronicle Books LLC
680 Second Street
San Francisco, California 94107
www.chroniclebooks.com

I dedicate this book to my mom. She always encouraged me to explore my creativity, which made me believe that *everything* was possible. Soon, the whole world became my hobby shop.

YOU ARE AN ARTIST.

I was born the fourth of five. It went: girl. girl. girl. *me.* boy. It was no secret that my parents were hoping that I would be a boy, but such was fate, both theirs and mine. Trying to compete for attention with three older sisters and a prized baby boy proved beyond impossible, and I gave up trying early on. I believe it was this birth order that shaped my personality: *painfully* shy, an introvert, and always in my own little world. I felt unseen and unheard.

But, I was encouraged to be creative from the very start. A big part of our life was centered around music and art and I feel fortunate that I was able to tap into my creativity at such a young age. I could hide behind it, lose myself in it, and not have to talk or be out in the real world. Art was the channel that connected me to the world and to myself.

Along with having us start piano lessons at age four, our mother took us on weekly trips to the local hobby shop. There, we were allowed to choose any project to pursue. I remember being enchanted and overwhelmed by the rows and rows of endless possibilities. Paint-by-numbers sets (I can still smell the little squares of oil paints), model airplanes, paper dolls, macramé, hook rugs, Shrinky Dinks, an Easy-Bake Oven, and the list went on. I would easily lose myself in a project for hours on end.

We are all born artists.

Children need no artistic instruction. When you put a crayon in a two-year-old's hand, they instinctively begin to draw. There is no hesitation, no inhibition, no resistance. They don't say "I don't know *how* to draw, I don't know *what* to draw." Two-year-olds are my role models—they don't compare and they don't critique what they create. They are happy and proud of their art. They simply and fearlessly draw with abandon, enthusiasm, and pure joy.

I count myself lucky that I managed to hold on to this kind of joy while navigating my way into adulthood on my own terms. I think an art education can be beneficial for many, but I chose a different path. I didn't go to art school and have never had a drawing or painting class. I believe that because I was truly

uninformed it allowed me to make and break my own rules. There was no right way and there was no wrong way. Because I loathe following rules, I instead followed my intuition. It was imagination, experimentation, and curiosity that paved my way.

As we grow older, parts of our innate creativity fade. We develop inhibitions and become guarded; for some, it is out of humiliation or fear, for others, it might be about comparing ourselves to a fictitious standard and not living up to expectations. We often listen to, and believe, negative feedback, and this only widens the gap between our inner artist and our adult persona.

I think there is a way to get back in touch with our authentic two-year-old inner artist, and it's easier than you think. Because we were born with a creative instinct, the connections to our creative roots are always accessible. We all have the ability to bring more art and creativity into our lives. Whether you were the fourth-born or the firstborn, whether you have never been to a museum or you go every week, we all just need a place to start.

Draw from the inside out, from an emotion or a feeling.

Draw what *you* are drawn to.

Draw like nobody will ever see what you drew.

Draw every day.

There is no right or wrong way to draw. There are no rules in art. I'm not even giving you rules in this book. I'm merely showing you some of the things that work for me, to make my art practice fulfilling. The more you draw, the more confidence you will have. Soon, drawing will come as naturally and authentically as it did when you were two. I find that the quicker I draw, the better the results. Don't overthink and don't hesitate. I am opening up my sketchbooks and sharing some of the things that I do to seek inspiration. Perhaps this will help you find somewhere to begin . . .

Seeing Beauty.

It is entirely possible to see beauty in things that might often be considered flawed. Sometimes that means honing in on the smallest detail to find its beauty: the dotted skin of a rotten banana, an oxidized washer, a faded piece of fabric. Sometimes we just need to look closely and observe with intentional curiosity to discover the unanticipated. I have always believed that every person possesses at least one beautiful physical attribute and I feel this, too, about every*thing*. As a visual thinker, tactile things draw me in: tattered ephemera, rusty objects, decayed things. To really see an intriguing object, pick it up, turn it over, take it out of its element, study it closely, and focus in on its unique qualities. Becoming aware of the textures, the colors, the shapes, and the outwardly awkward beauty marks all make for an enticing object worth documenting.

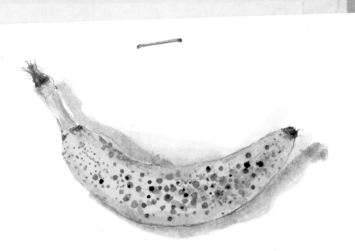

the more ripe, the more beautiful.
...let's think of each other as bananas.

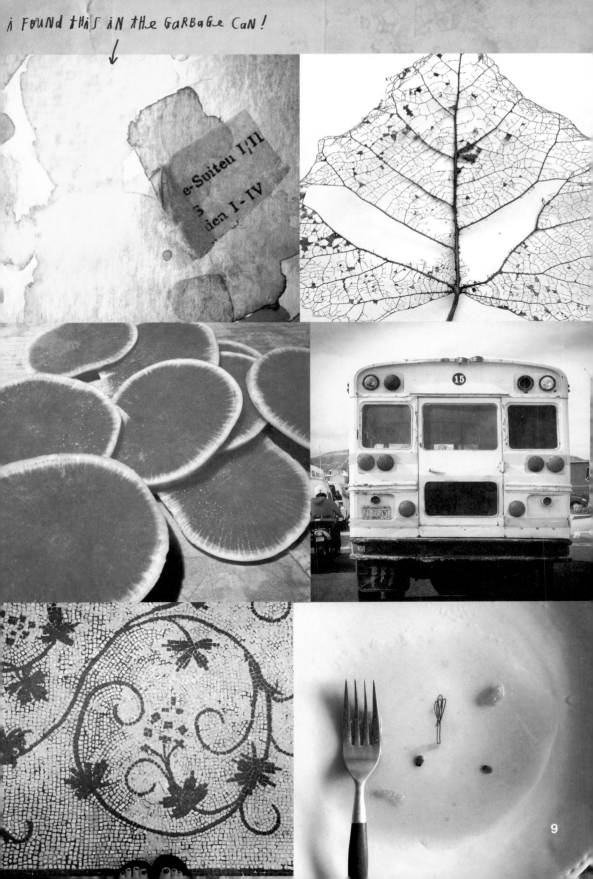

i FOUND tHIS iN tHE GARBaGE CaN!

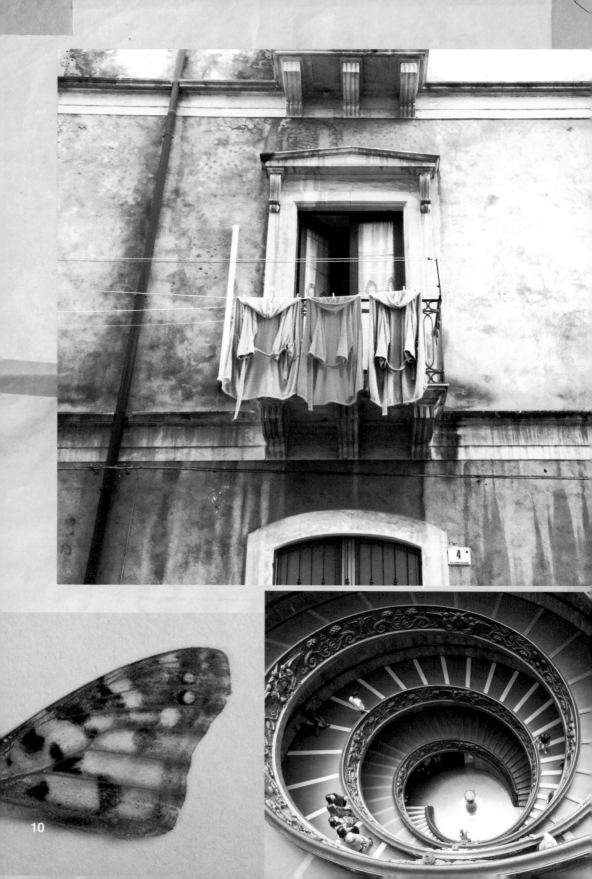

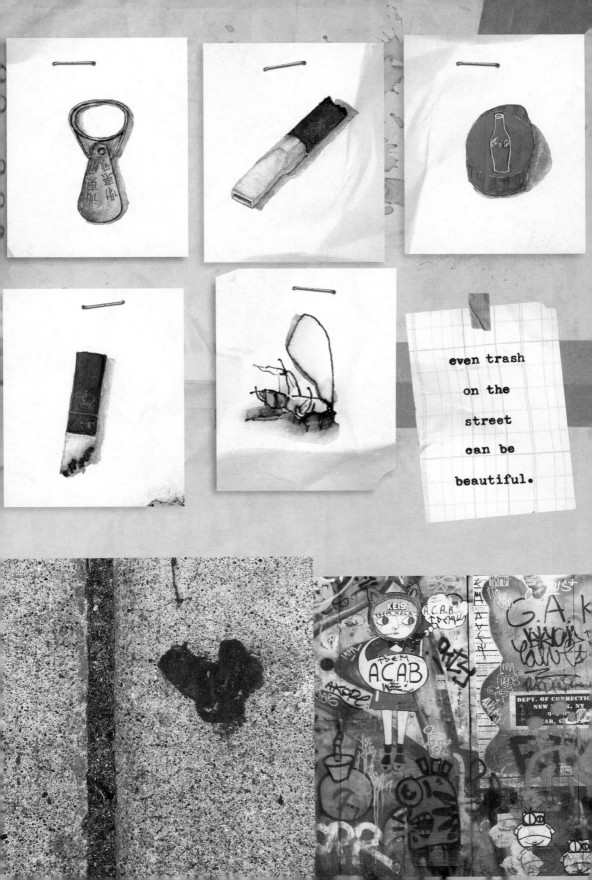

even trash

on the

street

can be

beautiful.

the GUM TReE iN PHilaDeLPHia.
So GROSS ...But So BeAUtifuL. ↓

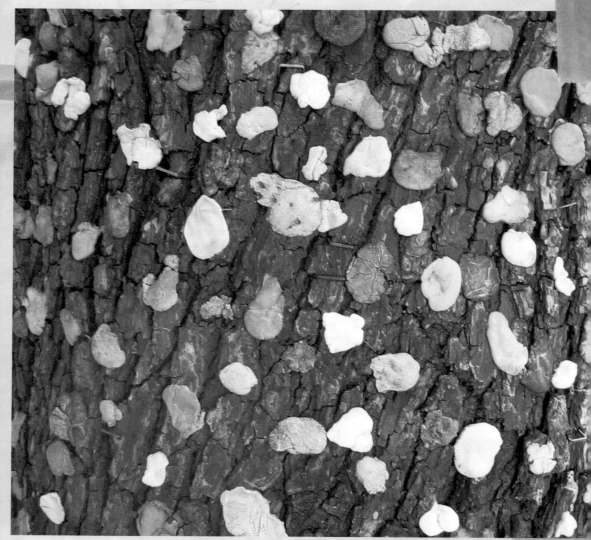

12

MoRNiNG RitualS.

A series of morning rituals sets the tone for the rest of the day. These rituals get me into the flow and inspire creative energy. I am not one who leaps out of bed and immediately dives into the day; rather, I like to slowly ease into the day with calm intent. My rituals begin the minute I wake up, and I rise early to make time for them because it's important to me. First I have tea in bed while writing down my dreams and jotting notes for the day. Next I play the piano, which puts me into the deepest and most satisfying state of creative flow. I take my dog, Wilma, for a walk, and then I get some exercise myself—I'll go for a run, roller-skate, or take a yoga class. Physical exercise has a way of emptying my head and making room for clear and concise thoughts. Sticking to this regular morning routine fully prepares me to start my workday. It's surprising how much of a difference a morning ritual can make on the rest of your day.

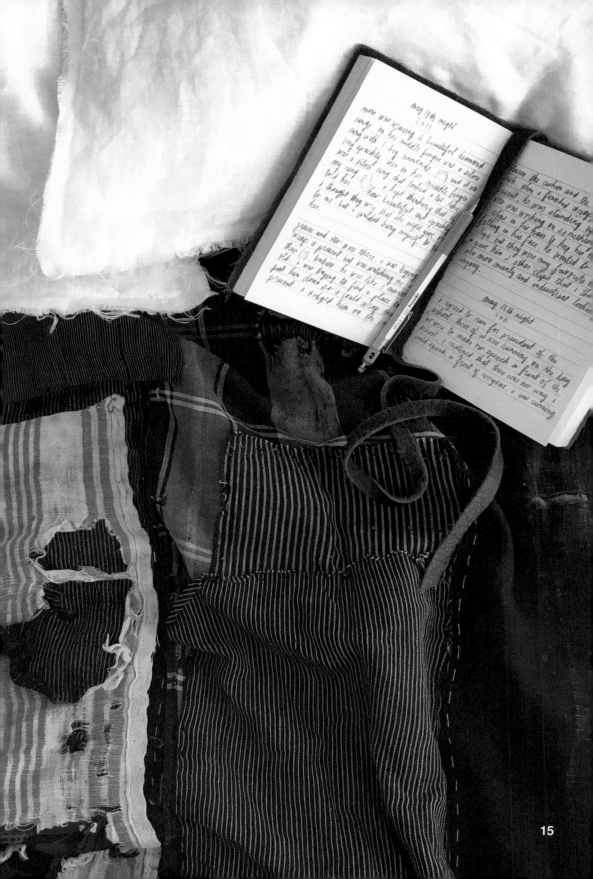

may 19th night
2011

mom was wearing a beautiful diamond
rings on her middle finger was a silver
ring with 3 big diamonds and it was
very sparkly. also on her pinkie finger
was a silver ring that looked a lot like
my own. I kept thinking about
her beautiful and sparkly
I thought they were that she might give one
to me, but I couldn't bring myself to
her.

peace and sits was there. I was trying
wrap a present but was watching me
them (?) babies he was like 3 months
old. I was trying to find a place to
put him down so I could wrap the
present. I nudged him on the

from the cushion and the
each. when I finished wrap
present. he was standing up
Otis was working on something
clips in his hair to keep his hair
falling in his face. he wanted to
clips but they were my favorite cl
gave him 2 other clips that, the
into more manly and industrial looking
anyway.

may 18th night
2011

I agreed to run for president of the
school. three of us were running, on the day
we were to make our speech in front of the
school. I realized that there was no way I
could speak in front of everyone. I was running

15

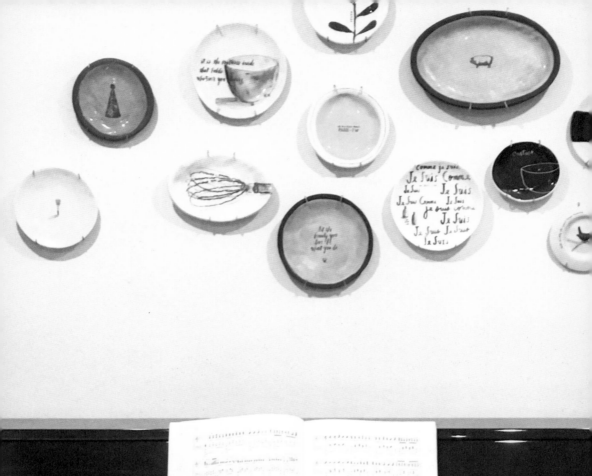
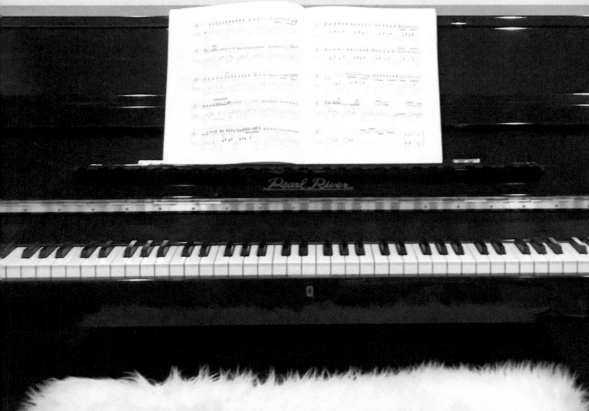

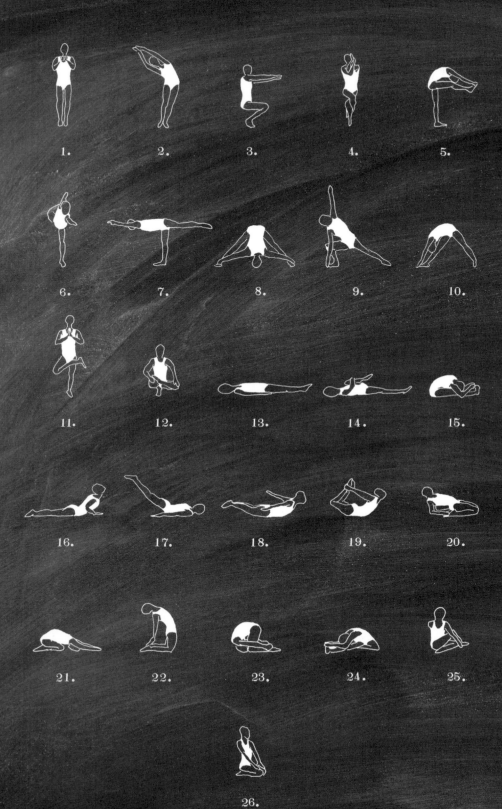

1.

2.

3.

4.

5.

6.

7.

8.

9.

10.

11.

12.

13.

14.

15.

16.

17.

18.

19.

20.

21.

22.

23.

24.

25.

26.

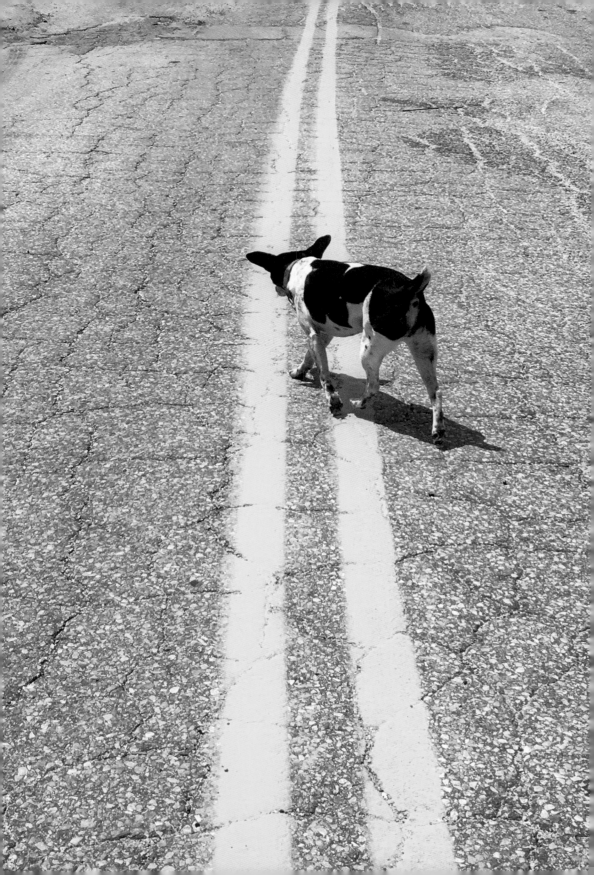

See.
DraW.
RePeAt.

I like to devote an entire sketchbook to drawing one object over and over again. This teaches me how to really "see" something, and, eventually, even how to think about that object differently. I draw from numerous angles, different perspectives, with diverse lighting, and with various art materials. I stay with this one object as I study it, really get to know it and understand it, as it slowly reveals itself to me. If you try this practice you'll find that even though there are hundreds of versions of one simple thing, every drawing is different and holds its own unique characteristic. I love looking through these finished sketchbooks to see the incredible variety of subtle emotion and personality of the same object. Here, I chose an alluring antique French key to draw again and again . . . and again.

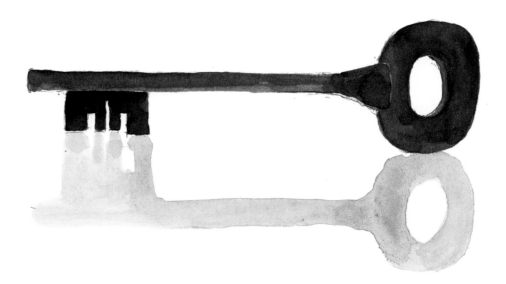

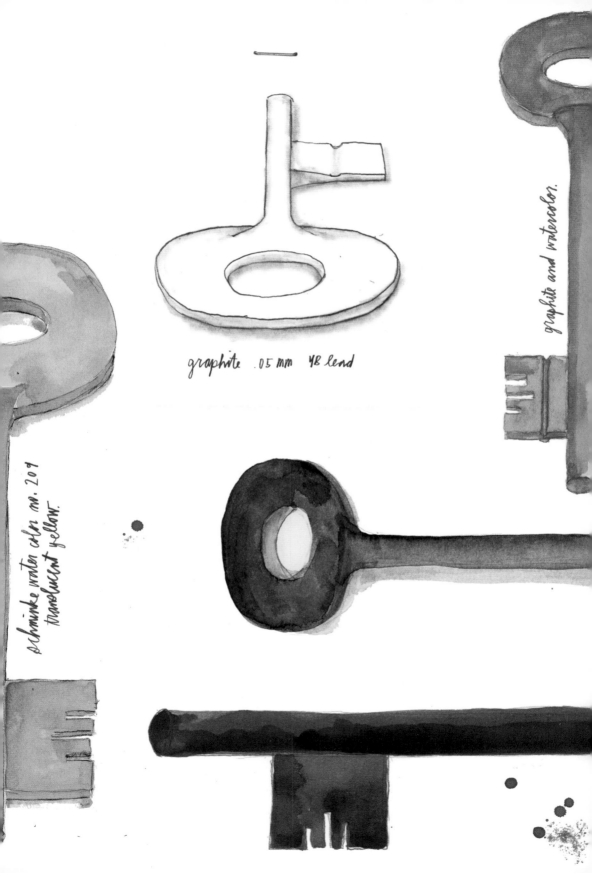

graphite .05 mm 4B lead

graphite and watercolor.

schminke water color nr. 209
translucent yellow.

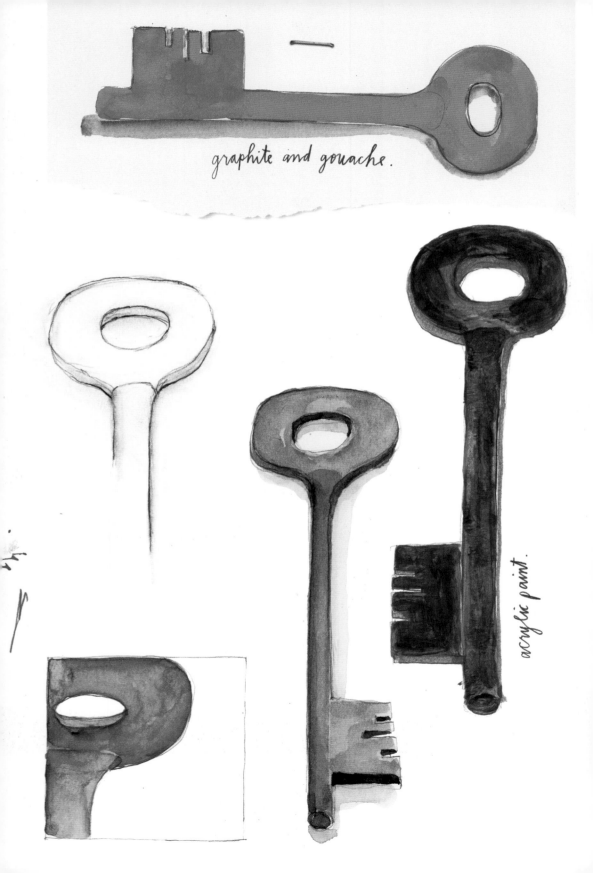

graphite and gouache.

acrylic paint.

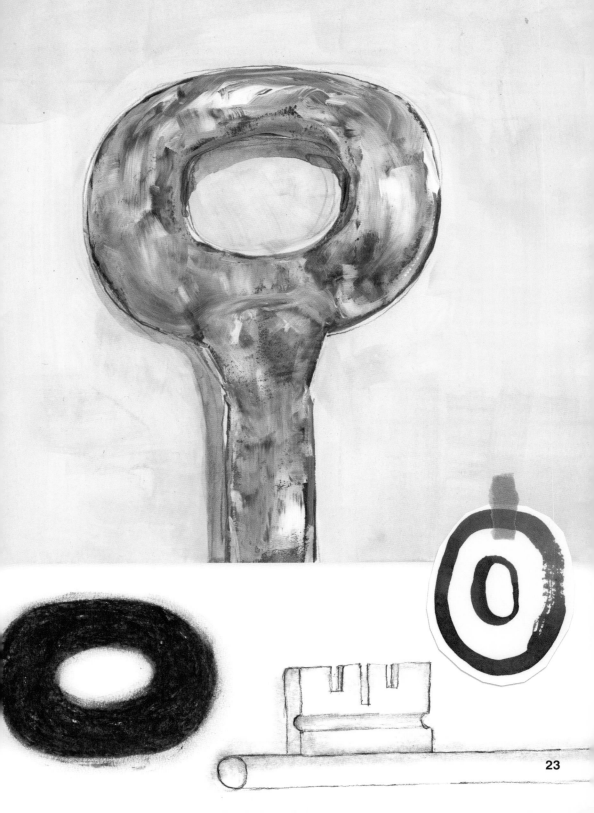

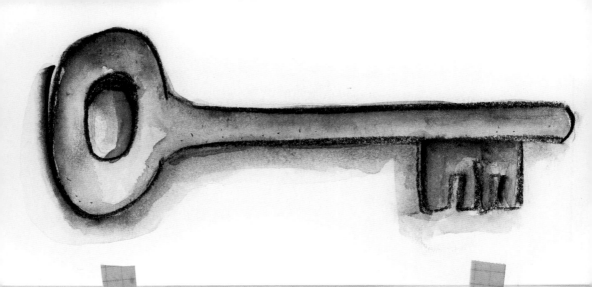

JAN 1 1 2014

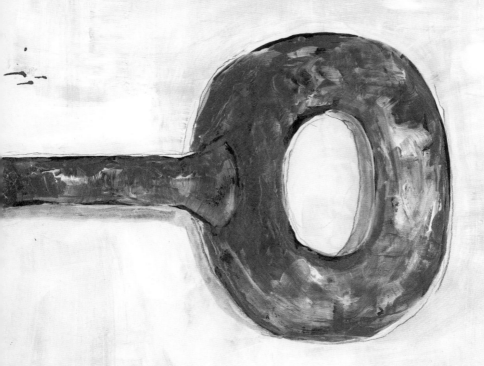

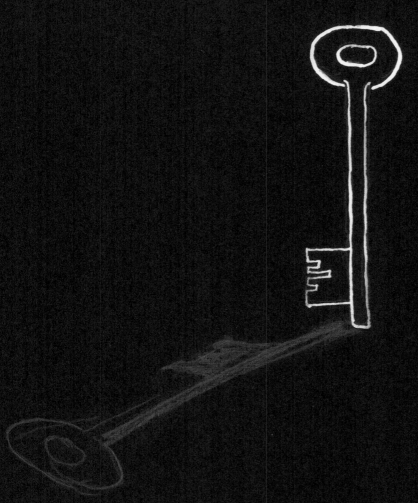

NON-DOMiNaNt HaNd.

On these pages, I drew, painted, and wrote everything using *only* my non-dominant hand. For me, it is my left hand. It feels very awkward at first. My line is wobbly, but it has a naiveté that I find very appealing. I always use a pen so that I am not able to erase *anything*. This is a great way to exercise the other side of your brain. It taps into your two-year-old inner artist where neither inhibition nor self-consciousness exists. I'm not expecting great results, so I'm not overthinking or trying too hard. This is exactly when the best results happen. You'll be drawing with your intuition and feeling. Notice how charming your drawings really are!

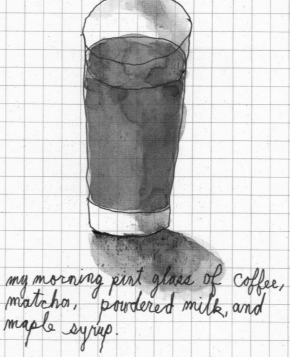

my morning pint glass of coffee, matcha, powdered milk, and maple syrup.

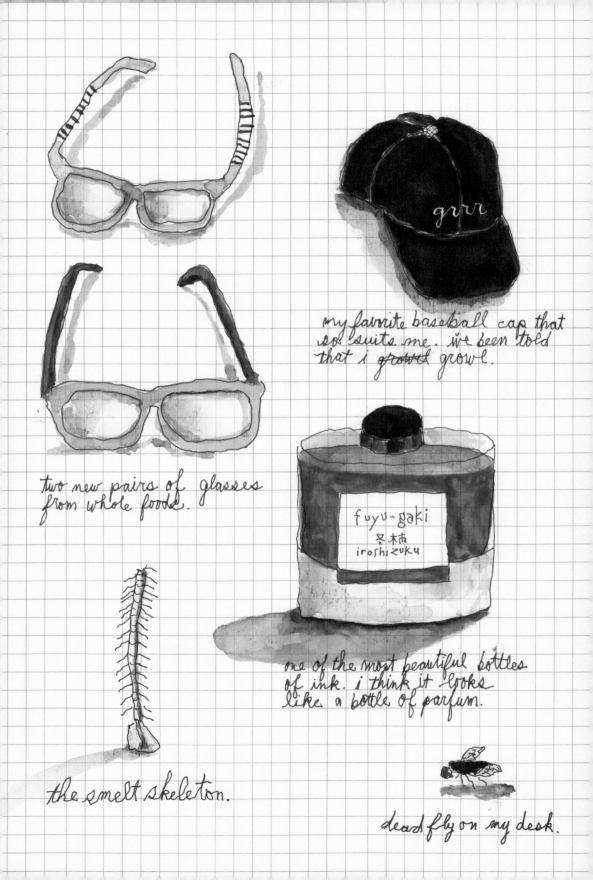

my favorite baseball cap that so suits me. ive been told that i growl growl.

two new pairs of glasses from whole foods.

fuyu-gaki
呂 柿
iroshizuku

one of the most beautiful bottles of ink. i think it looks like a bottle of parfum.

the smelt skeleton.

dead fly on my desk.

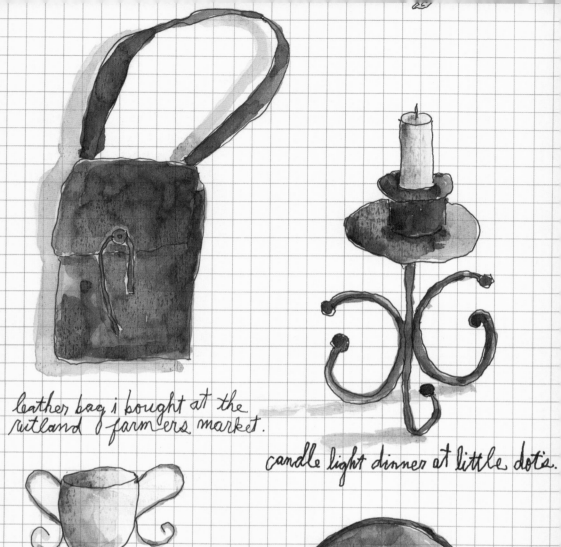

leather bag i bought at the
rutland farmers market.

candle light dinner at little dot's.

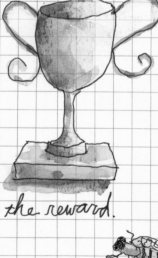

the reward.

such busy bees.

i will never have too many
wooden boxes!

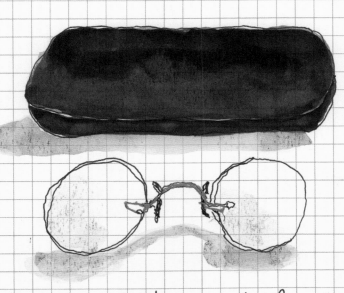

i bought these spectacles at
an antique shop in
middlebury, vt. i find them
to be so beautiful and
elegant.

$5.⁰⁰

i bought this old ice pick at my
new favorite antique store in
middlebury, vermont.

$1⁰⁰

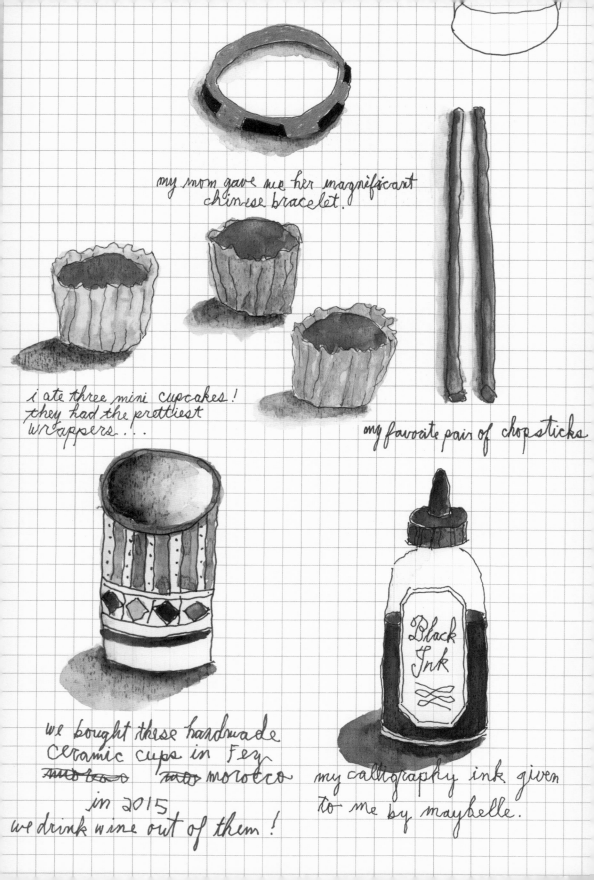

my mom gave me her magnificant
chinese bracelet.

i ate three mini cupcakes!
they had the prettiest
wrappers...

my favorite pair of chopsticks

we bought these handmade
ceramic cups in Fez
~~and too~~ ~~and too~~ morocco
in 2015
we drink wine out of them!

Black
Ink

my calligraphy ink given
to me by maybelle.

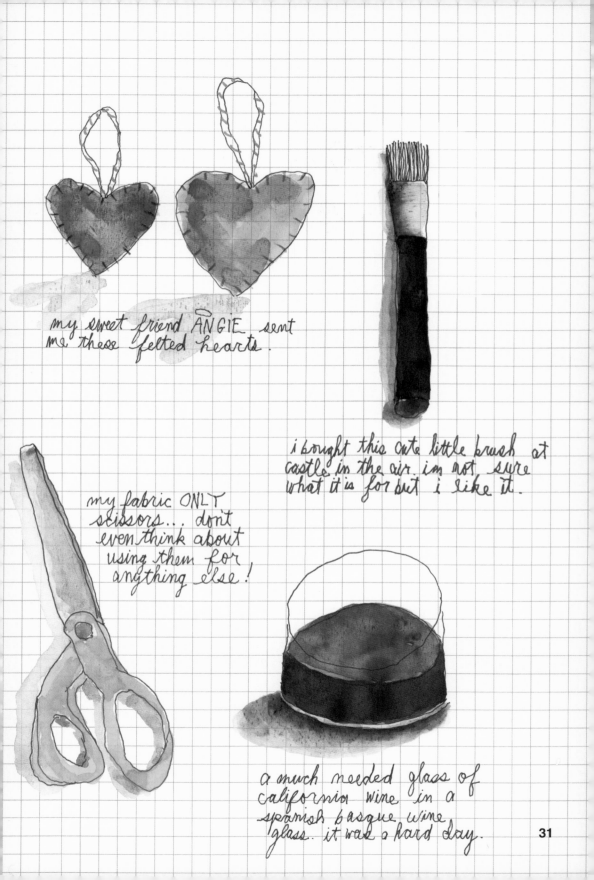

my sweet friend ANGIE sent
me these felted hearts.

i bought this cute little brush at
castle in the air. im not sure
what it is for but i like it.

my fabric ONLY
stissors... don't
even think about
using them for
anything else!

a much needed glass of
california wine in a
spanish basque wine
glass. it was a hard day.

31

FooD FoR tHouGHt.

I grew up in a restaurant. This is where my earliest childhood memories are set. My dad and his brother owned and operated two restaurants for more than thirty years. Needless to say, food was always a very significant part of my life. My father was an extraordinary chef who cooked dinner for us at home every single night. These nightly and often chaotic dinners were magical. A time for our family to come together, converse, and savor a delicious meal. It's no surprise that food has become my favorite thing to draw. I love the various shapes, colors, and textures of different types of foods. I spend hours in gourmet food shops sketching the cheeses, the charcuterie, the fish, the produce, and the pastries. If you are ever in doubt of what to sketch, simply draw what you eat!

- THANK YOU -
- -

Subtotal	$49
Saba Shioyaki	$17
Hamachi Sashimi	$19
Sunomono	$ 4
Edamame	$ 2

RECIPE for a sweet to be served in individual glasses. (MRS.) F. Ilkeston.

MaGNiNi PiZZa.

smoked salmon

fresh dill

mozzarella

mascarpone

my dad rang this bell every night
to gather our family for dinner.

mossy brown

muddy orange
pale
yellow

tomme de fedous.

cabrichanne.

bleau.
cheddar
orange

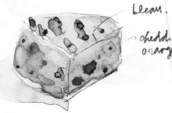

purple brown

palest
yellow/white
a bit of bleu

queso manje.

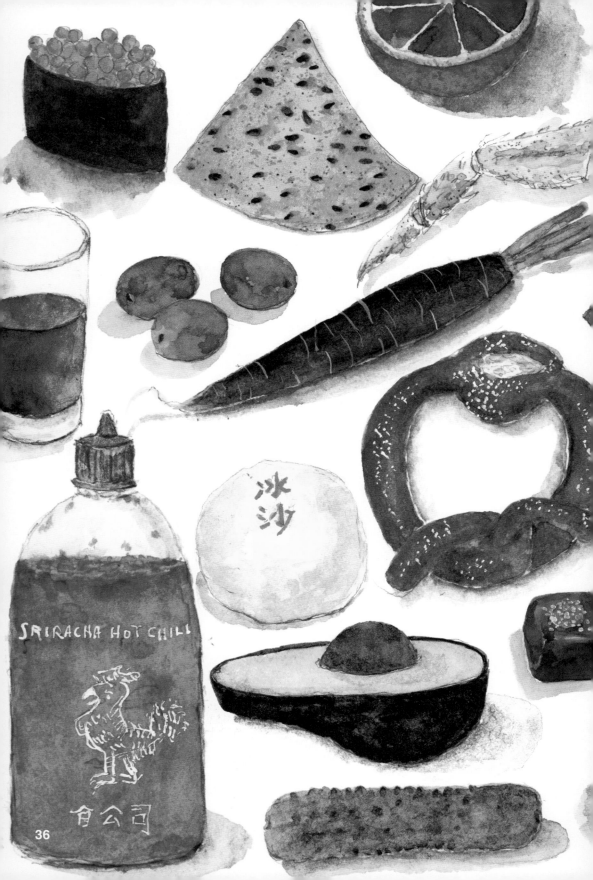

SRIRACHA HOT CHILI

冰沙

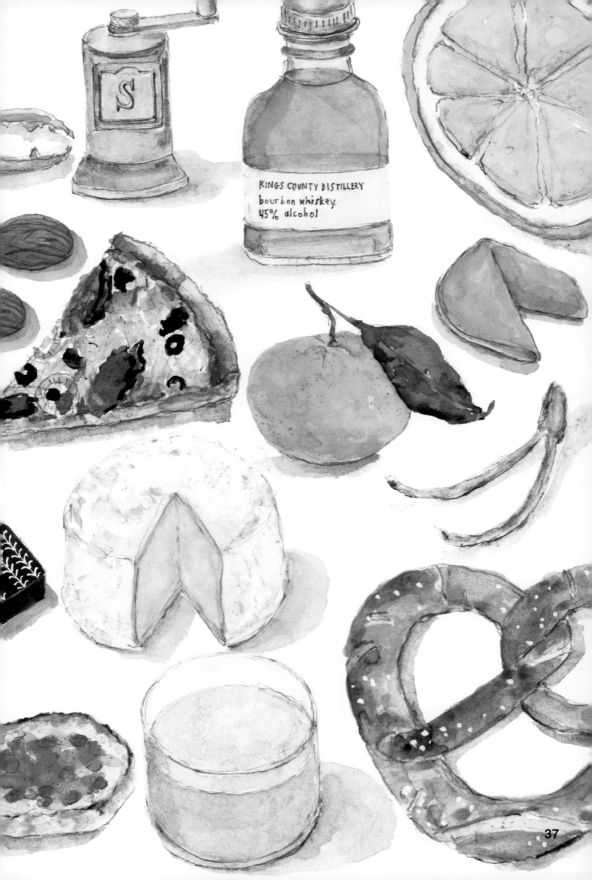

KINGS COUNTY DISTILLERY
bourbon whiskey.
45% alcohol

CoLLeCtioNS.

What we collect tells so much about us. I have always been a collector. I like series of things. I like documenting. I like differences in sameness. I have a wide range of objects that I have collected over the years. Most of the things I collect are old or obsolete. I have a penchant for preserving, connecting with, and honoring things from the past. It's a way for me to keep small parts of history alive. It's so satisfying to find a piece to add to my collection while in a faraway place or by complete surprise. I will often refer back to these objects and draw inspiration from them as they spark new ideas.

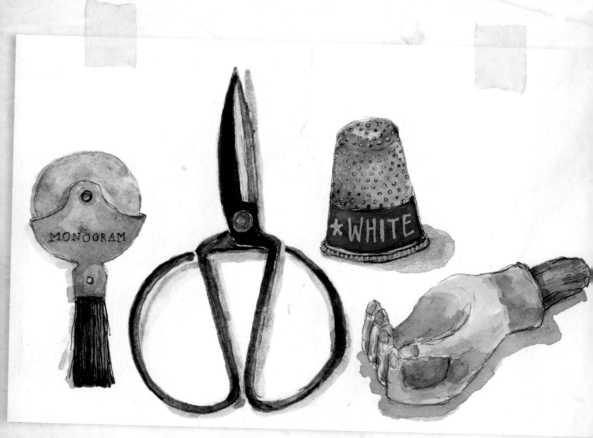

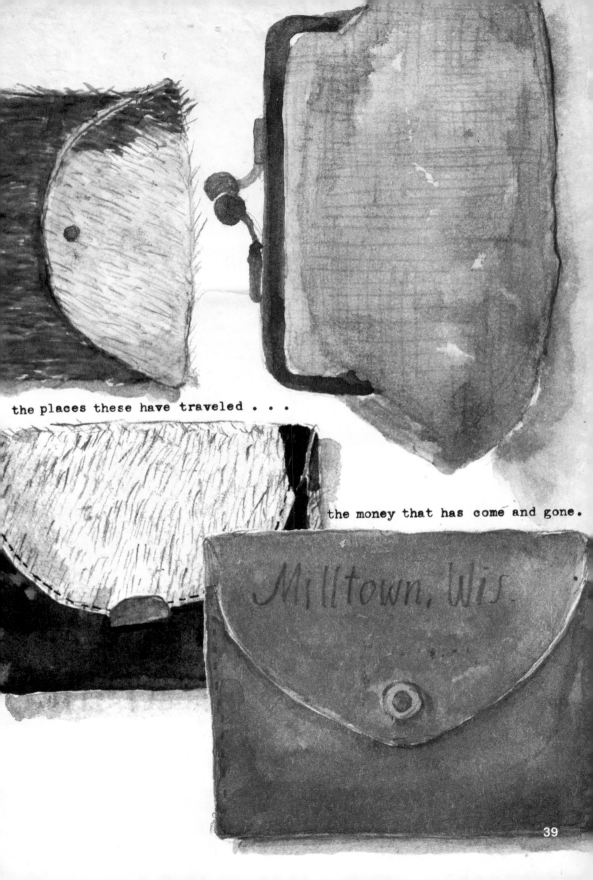

the places these have traveled . . .

the money that has come and gone.

Milltown, Wis.

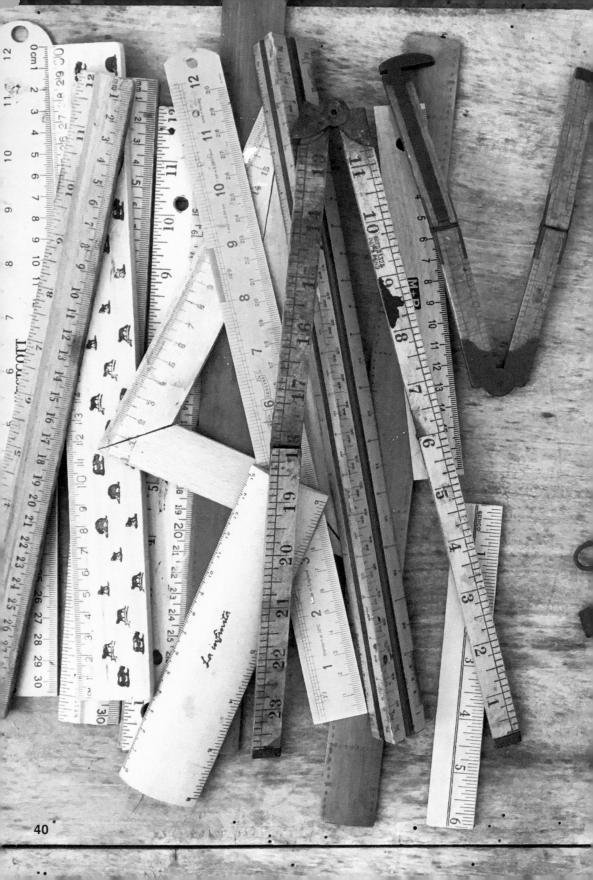

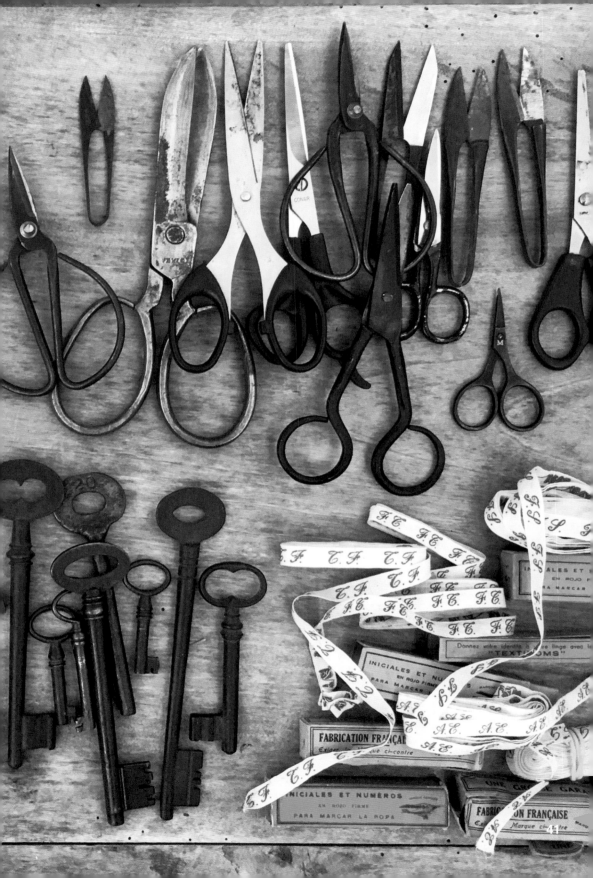

41

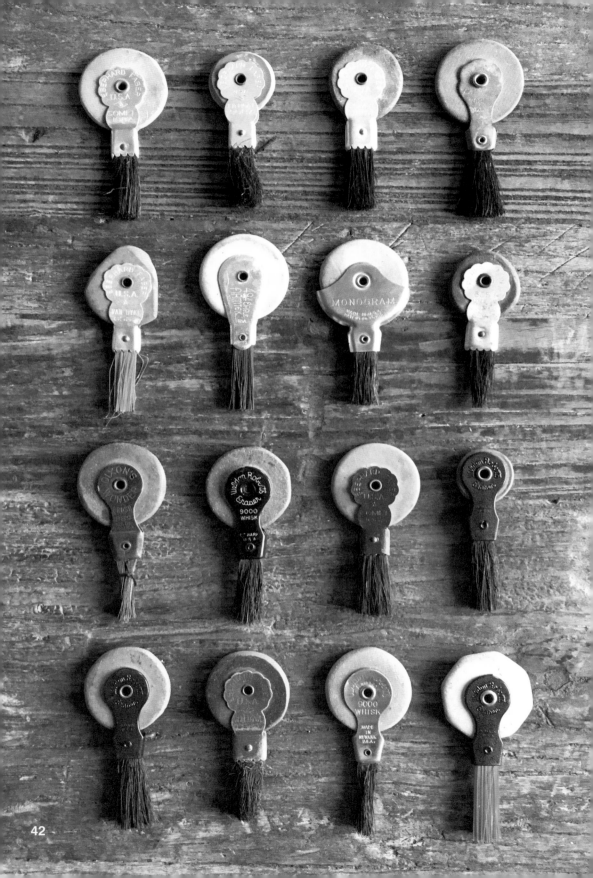

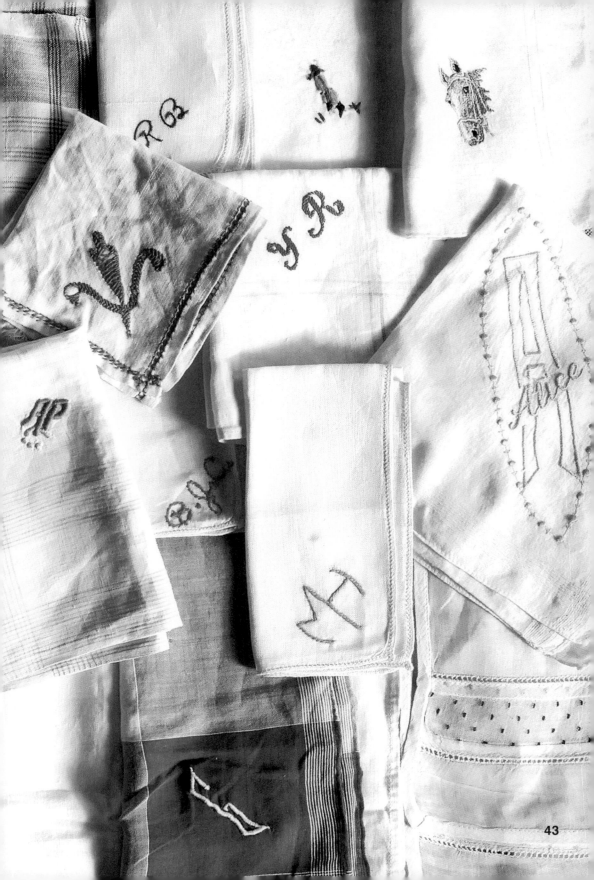

SketCh du JoUR.

On January 1, 2017, I decided to start a daily project that I called
"sketch du jour." I drew one quick watercolor sketch every single day for
a year. To keep me accountable to this project, I posted the sketch daily
on Instagram. This made it harder for me to quit when I was so "over
it!" The first one hundred days were remarkably easy, but after the
honeymoon period, many days were a serious struggle. This challenge
taught me how to push through a creative block, how to see beauty in
things that I might have overlooked, and showed me the rewards of
not giving up. When you challenge yourself to exercise your creative
muscle every day, I promise you will be rewarded.

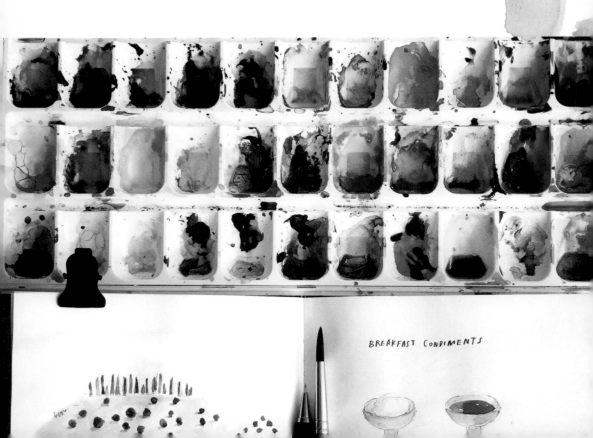

BREAKFAST CONDIMENTS.

if you do just one sketch
every day, soon you will
have volumes of sketchbooks.

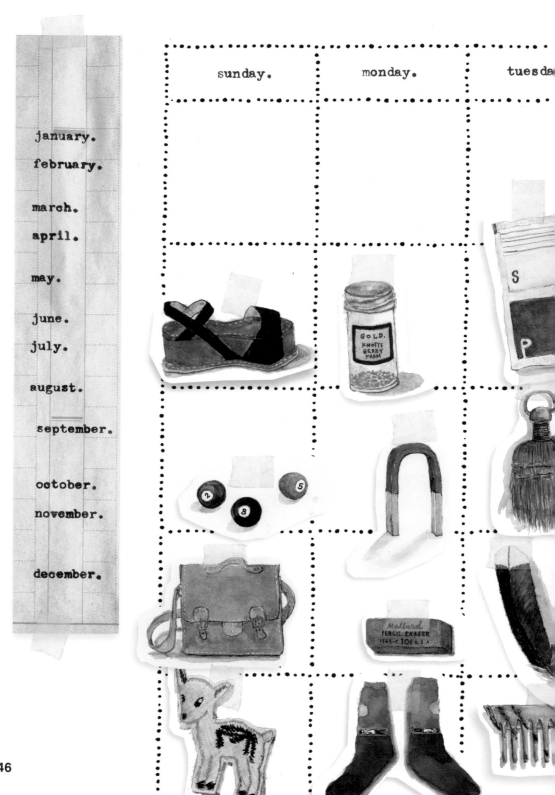

january.

february.

march.

april.

may.

june.

july.

august.

september.

october.

november.

december.

	sunday.	monday.	tuesda

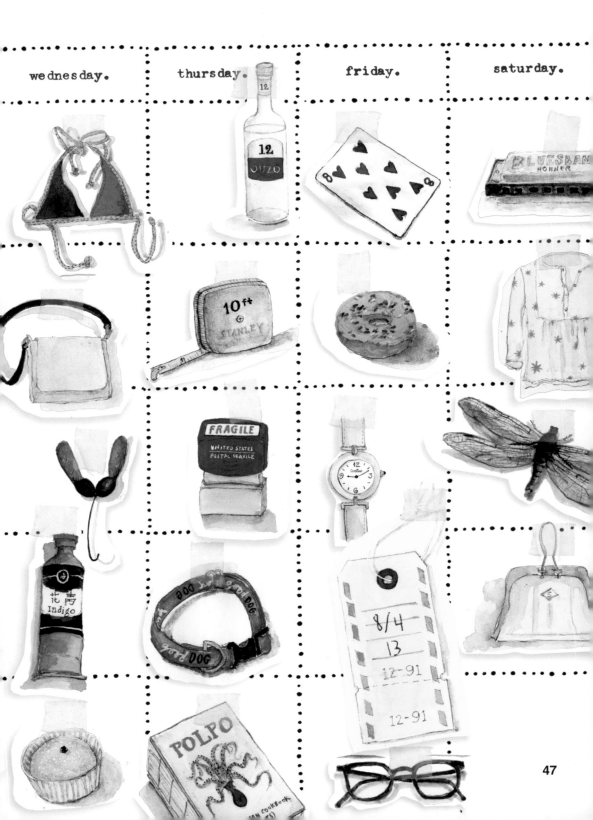

wednesday. thursday. friday. saturday.

47

SEP 02 2017

this cute mint from china.

AUG 24 2017

i got five rusty horseshoes at the local junkyard.

JUN 26 2017

YIELD TO THE ART

my new journal from cartoleria pantheon.

FEB 17 2017

dried jujubes from auntie sallie.

MAR 24 2017

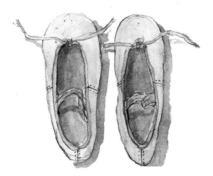

baby ballet slippers.

MAR 05 2017

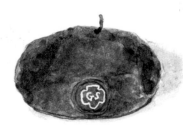

i found my old girl scout beret.

APR 1 6 2017

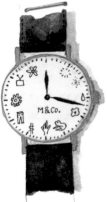

i've had this watch for 27 years.

MAY 2 0 2017

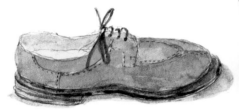

MY PARABOOT SHOE FROM 1990 that i LOVE NOW JUST as an OBJECT.

APR 1 7 2017

it's the PERFECT DAY to WEAR MY CASHMERE ERICA tANOV HAT...

NOV 2 2 2017

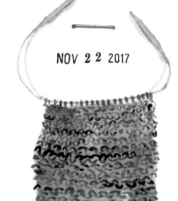

taking SOME TIME to WORK oN MY PONCHO.

MAR 2 5 2017

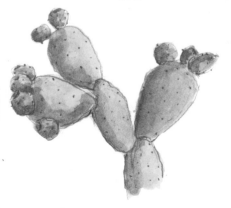

i LOVE PRICKLY PEAR CACTUS.

FEB 1 8 2017

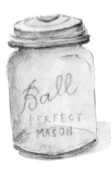

Ball
PERFECT
MASON

i COLLECT BLUE MASON JARS.

FLoRa aNd FauNa.

Without other living things, humans cannot exist. Plants generate and release oxygen, and animals produce and release carbon dioxide. They are not only inherent to one another's existence and our own, but they are also the most beautiful and perfect specimens that exist. The colors I see in nature simply take my breath away. Just walk out your door and you will be privy to this beautiful kingdom. Flora and fauna are at your fingertips and ready to be drawn: flowers, leaves, sticks, butterflies, bees, bugs, birds, insects, and more. The colors and shapes you find in nature are unequivocal and are the most natural and clear sources of inspiration.

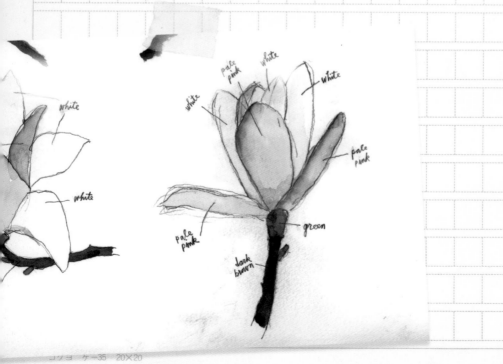

white

white

pale
pink

white

white

white

pale
pink

pale
pink

green

dark
brown

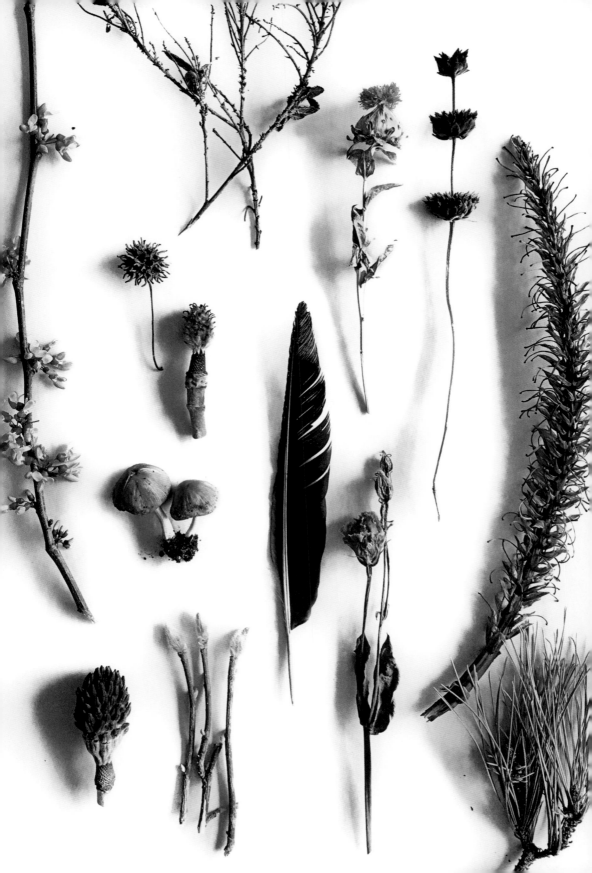

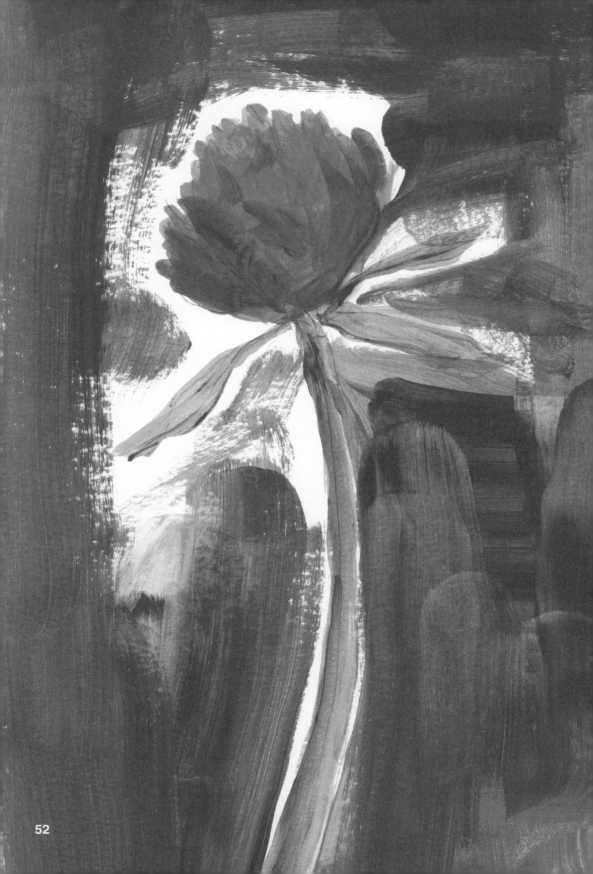

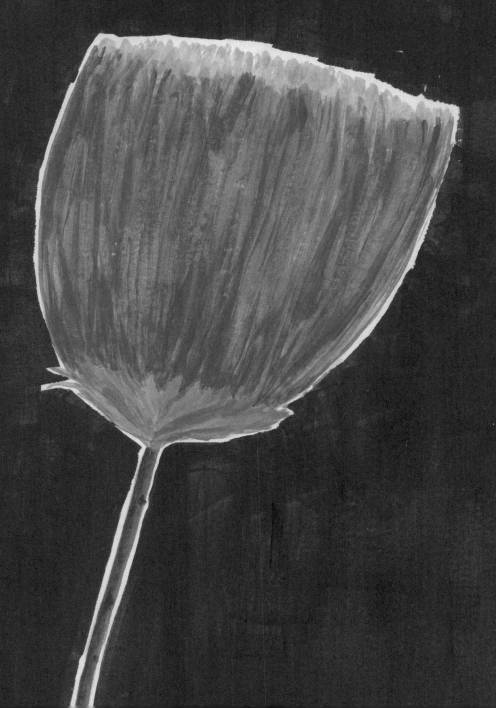

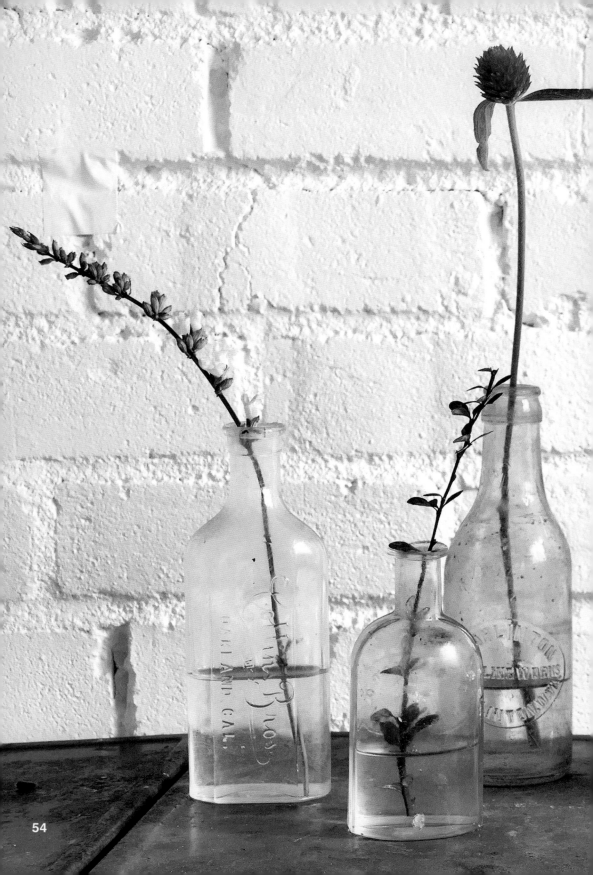

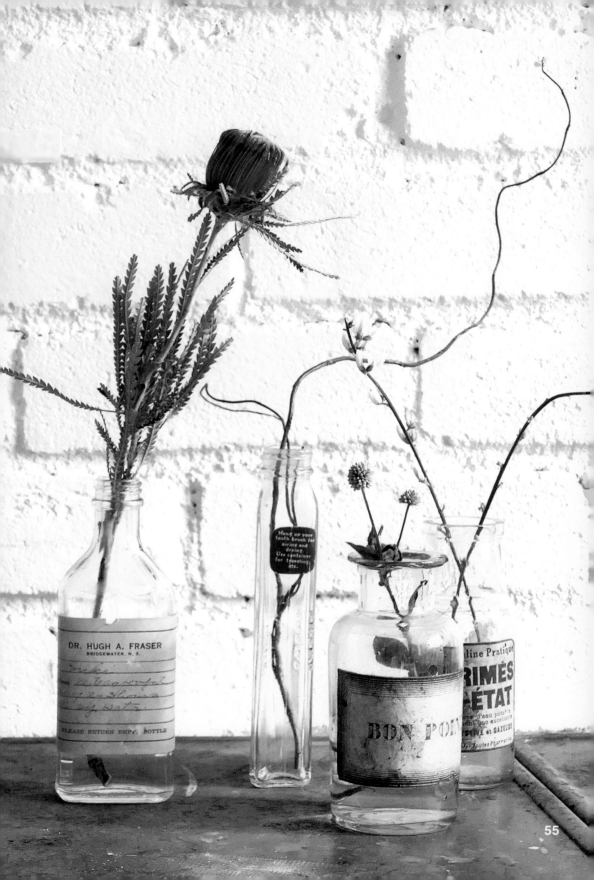

to tHe LetteR.

I have always been drawn to lettering, typography, fonts, handwriting, and words. It was this love of typography that led me to pursue graphic design. I once even hand wrote a résumé for a graphic design firm and was later told that was the impetus that landed me the job. Words are all around us: street signs, packaging, labels, newspapers, magazines, and the like. There are endless ways to interpret and reinvent the alphabet. Even just writing the alphabet over and over can lead you to discover a new way to form each letter. I have a couple of pen pals with whom I regularly exchange mail correspondence. This practice sparks so much joy, for the writer and for the recipient. The process of writing by hand gives such a strong connection to the words' inherent meanings, stronger than the act of typing ever could.

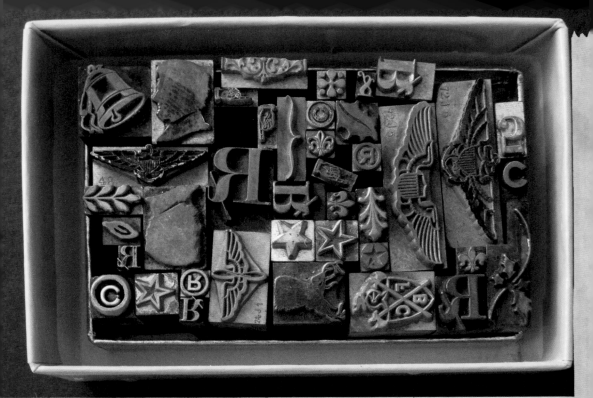

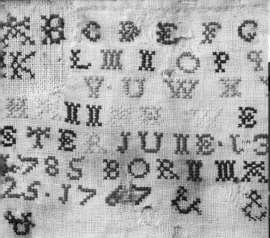

Neveria
ROCCO
Ice Cream
Coca-Cola

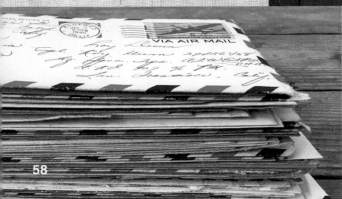

VIA AIR MAIL

Casa
Mare
35

ッ ン

IPPO Ramen

1. Shio 塩
2. Shoyu 醤油
3. Miso 味噌

$9

NO SMOKING WITHIN 25 FEET

停

RUBBER
Bands

ASSORTED
SIZES

s t a r n e t
駐 車 場

D

made in
Vallauris

ine

LOVE

BeGiN

Become

PONDER

know

WRite

WISH

dream

INSPIRE

FOCUS

KE

PERSIST

gh

PLAY

XPLORE

PICKLE

DraWN bY NatuRe.

Sticks, flower stems, leaves, feathers, rocks, and so forth make marks
unlike any pen or pencil ever can. I like to write with found objects to
achieve surprising and unexpected results. On my walks in the woods
or about town, I look for objects from nature that speak to me. I gather.
I dip the ends of the sticks and other objects into walnut ink, sumi ink,
or calligraphy ink and start to write or draw. I try making marks on
different papers. Can you imagine how people did things before the
inventions that are now so commonplace? Writing with a homemade
quill seems so romantic today. There's beauty in going back to this
earlier time, making marks that elude man-made instruments. On these
pages, each writing was done with an object from nature, and then I
sketched that same object with pencil and watercolor.

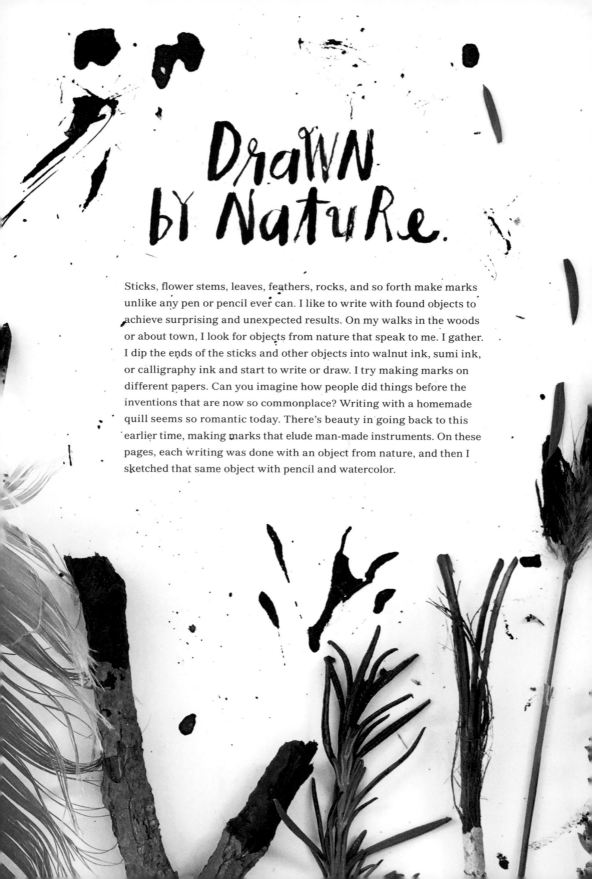

Be sure to put your feet in the right place, then stand firm.

abraham lincoln.

63

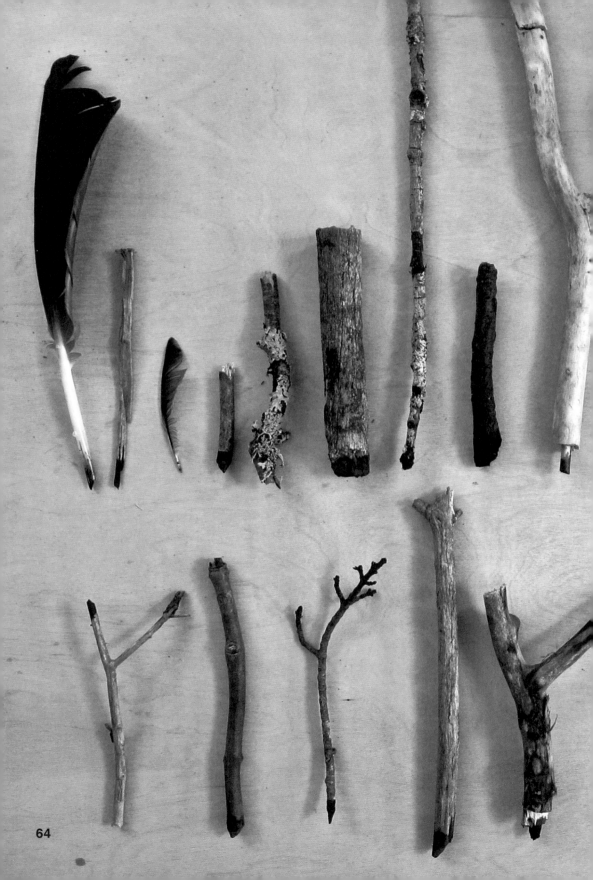

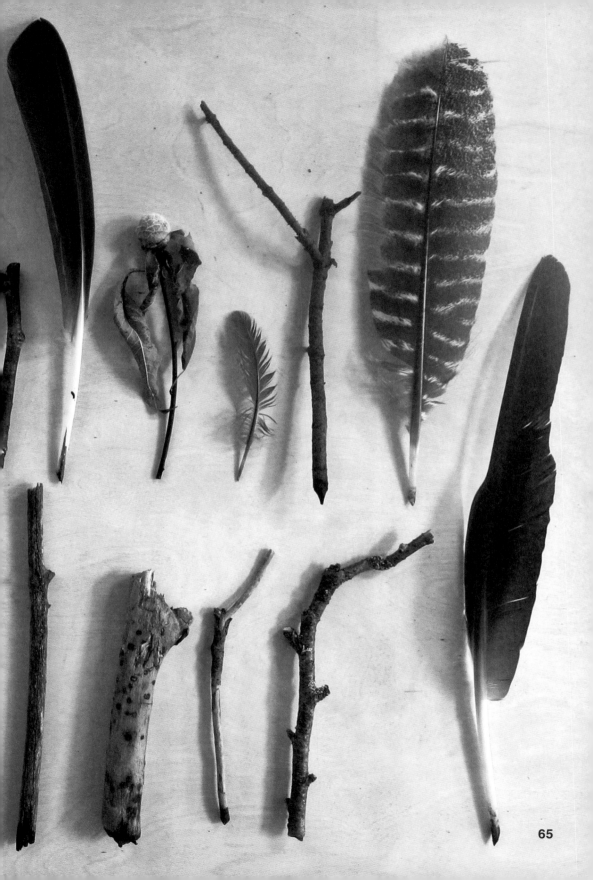

65

HaVe NO FeAR OF PeRFeCtioN.. You'LL NeVeR ReACH it.

salvador dalí.

MY toolBoX.

It took me some time to find my favorite tools—the pens, pencils, paints, paper, paintbrushes, sketchbooks, and glue that feel comfortable in my hands. It's important for me to have the right tools to make the art that feels like mine. I am very particular about the supplies I use. There are even a few things that I refuse to use: ballpoint pens (especially the blue ones), basic wooden no. 2 pencils, slippery or shiny paper. They could work for someone else, but they simply aren't *me*. The supplies you use have so much to do with your artistic practice. You don't need to spend a lot of money on fancy tools, but rather find the specific ones that work for you. You will learn by trial and error what you like and don't like, and soon you will know your favorite tools.

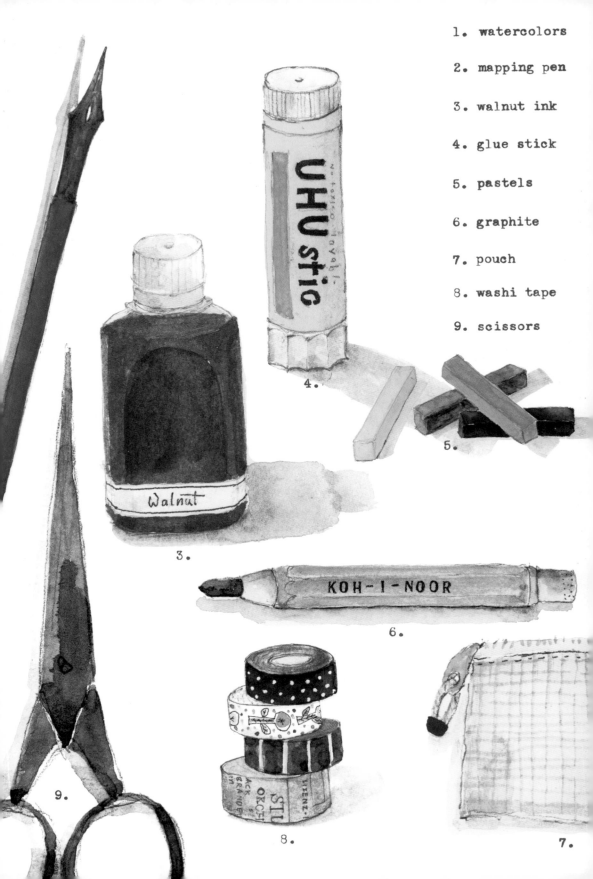

1. watercolors

2. mapping pen

3. walnut ink

4. glue stick

5. pastels

6. graphite

7. pouch

8. washi tape

9. scissors

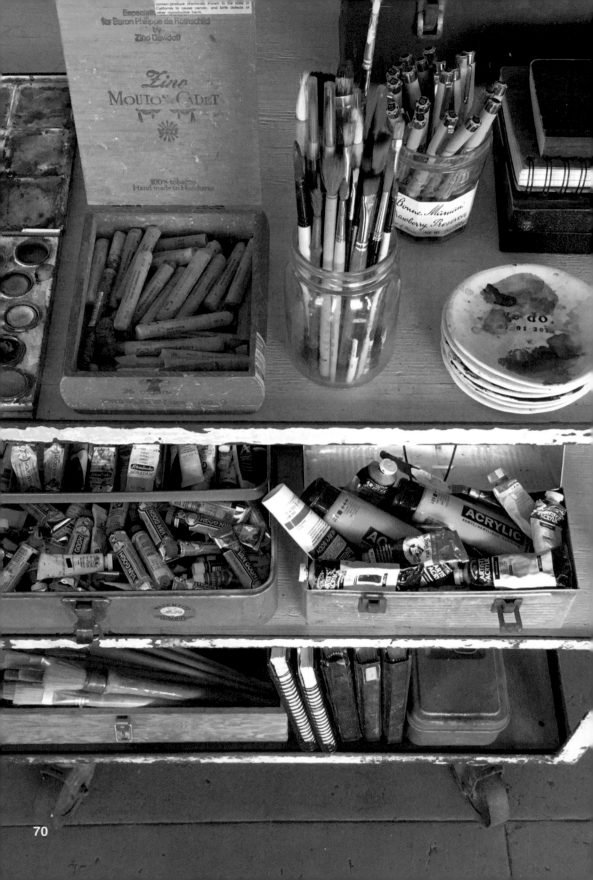

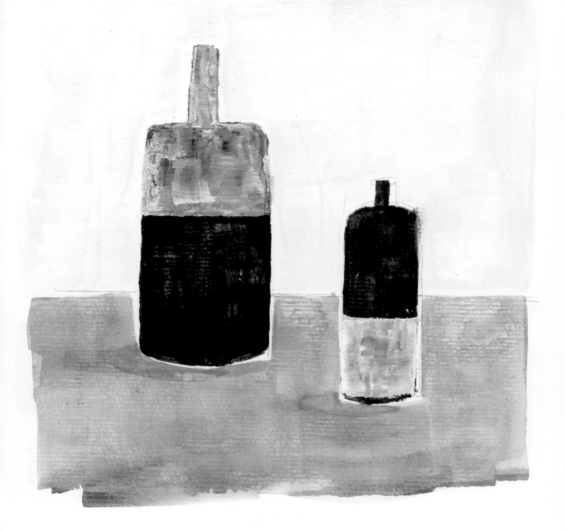

calmer dans le demi-jour.

i love using watered-down acrylic paints.
it creates a translucent effect that mimics watercolor.

OIL PAS
THEY L

WATERCOLOR IS MY FAVORITE MEDIUM. I LOVE ITS ELEGANCE and TRANSLUCENCY.

GOUACHE IS SORT OF LIKE WATERCOLOR, BUT HAS MORE PIGMENT and INTENSITY

PASTELS COME IN A WIDE RANGE
OF COLORS. THEY ARE FUN TO SMEAR
and BLEND. BECAUSE THEY ARE
PURE PIGMENT, the COLORS WILL
NEVER FADE!

MANY PEOPLE DON'T LIKE ACRYLIC PA
I LOVE ACRYLIC PAINT BECAU

YOU NeVER NeeD to SHARPEN!

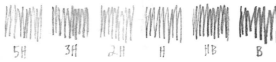

MY FAVORITE MECHANICAL PENCIL.
ROTRING 600 / 0.5 mm

5H 3H 2H H HB B

2B 4B 6B 7B 8B 9B

E VERY CREAMY and DENSE.
MIND AN INTERESTING TEXTURE.

the PITCH BLACK LUCIOUSNESS OF SUMI INK.

🔳 MICRON 01

MY FAVORITE BLACK PEN . . . I USE 01 and 005.

I ADD DIFFERENT
AMOUNTS OF BLACK INK
TO MY WALNUT INK TO
MAKE PERFECT SHADES
OF SEPIA.

MY STAPLE PAINT BRUSHES.

NUMBER 4 RED SABLE ROUND

NUMBER 0 RED SABLE ROUND

AUSE IT DRIES SO FAST.
DRIES SO FAST!

AHeRe i WaNdeR.

The places I go for inspiration are not the more typical museums or art galleries, but rather spots where what comes to me is completely unexpected. Ethnic grocery stores, flea markets, cemeteries, hardware stores, flower markets, to name just a few. Sometimes when in a very obscure place, I can find myself inspired by the most unexpected thing. But even the most ordinary of places have treasures to unearth. To make sure I'm prepared, I never leave the house without a sketchbook and pencil or my camera. I do quick rough sketches in real time, label the colors in pencil, and later fill in the sketch with watercolor based on my notes. When you look, you can find inspiration everywhere you go.

camel

white

ひかり字学肉

LE LABO
GRASSE — NEW YORK

fragrance
lab

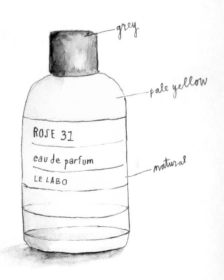

grey

pale yellow

ROSE 31

eau de parfum

LE LABO

natural

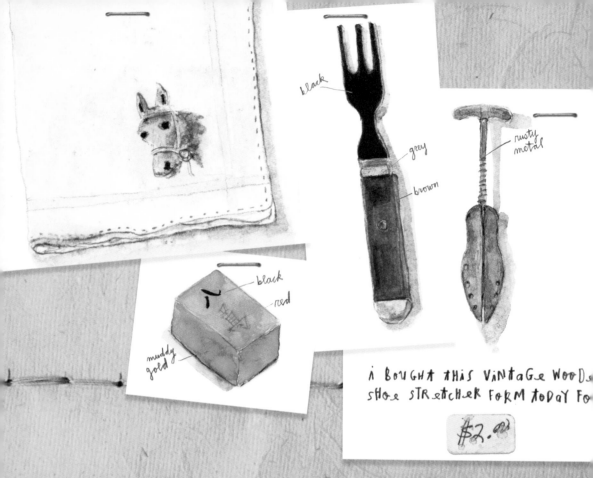

black

grey

brown

rusty metal

black

red

muddy gold

i BOUGHT THIS ViNTAGE WOODE
SHOE STRETCHER FORM TODAY FO

$2.00

i find the most unexpected things at a flea market. . .

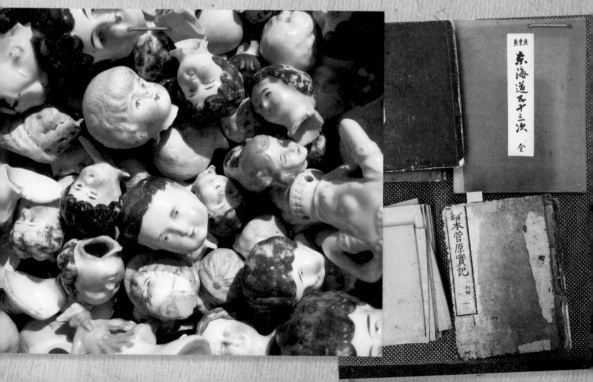

東海道五十三次

全

繪本菅原實記

初編
一

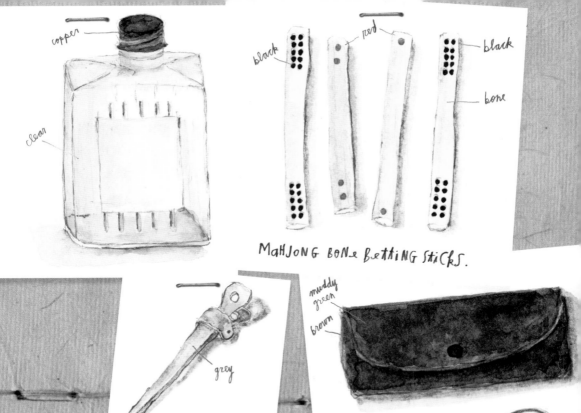

copper

clear

black

red

black

bone

MAHJONG BONe BeTTING STICKS.

grey

muddy green

brown

dirty copper

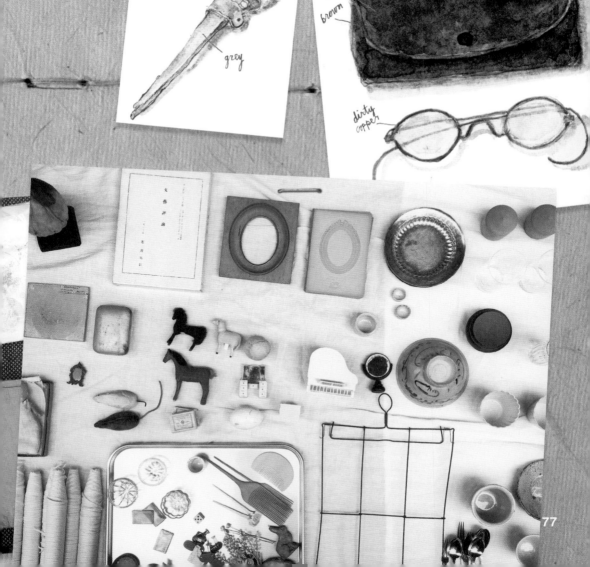

77

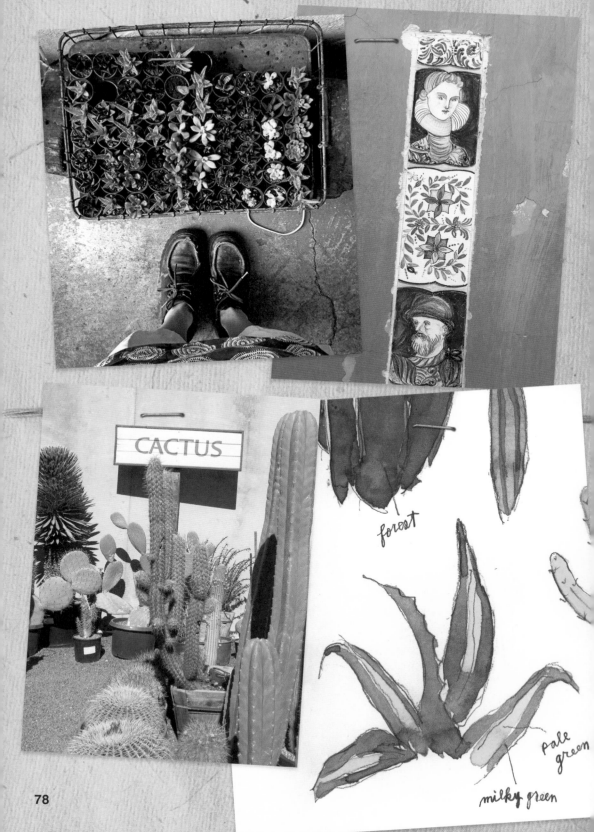

forest

pale green

milky green

CACTUS

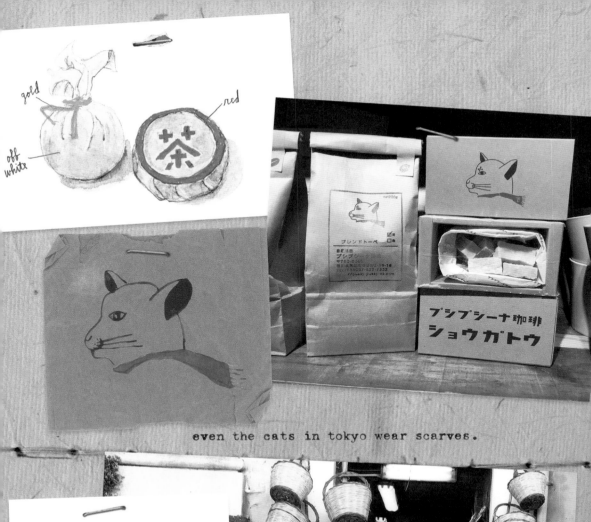

gold

red

off white

茶

ブレンドトーペ
プシプシ...
〒760-0063
香川県高松市...19-16
TEL(7)(087-822-7332
プシプシーナ珈琲.com

ブシプシーナ珈琲
ショウガトウ

even the cats in tokyo wear scarves.

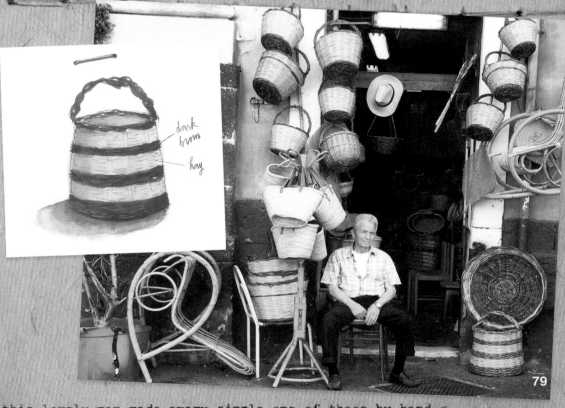

dark brown

hay

this lovely man made every single one of these by hand.

HoMe iS a MuSeuM.

No matter where you live, your home is like a museum, containing endless objects worthy of sketching. I keep a special sketchbook to chronicle everyday objects around my house. It's always available and ready for me to add a sketch of something that happens to catch my attention that day. These pages are filled with drawings of, and musings on, the mundane objects that surround me, from food in the pantry and light fixtures to patterns on the rugs and knickknacks. Some are as common as a rubber band, some as cherished as a family heirloom. Drawing these objects honors them, captures them in time, and is another way to tell the story of a life lived. Every person is their own curator and everything around us has some significance worthy of drawing.

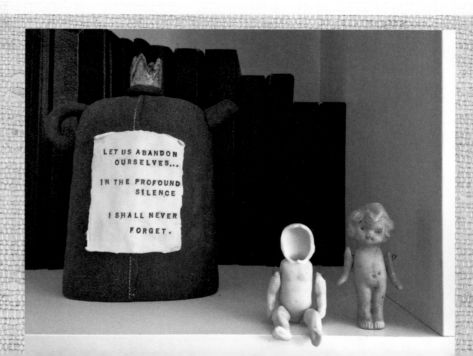

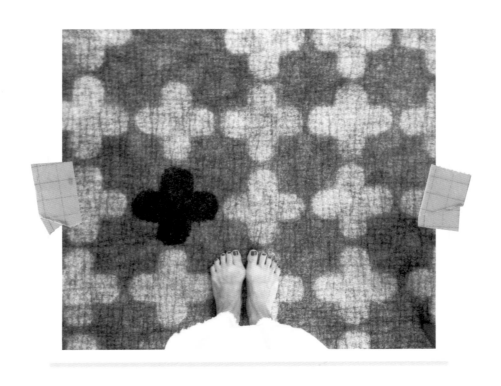

charcoal.

grey.

navy.

creme.

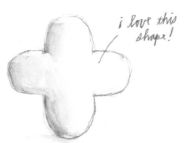

i love this shape!

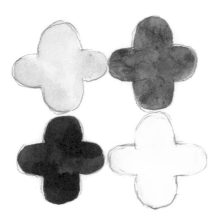

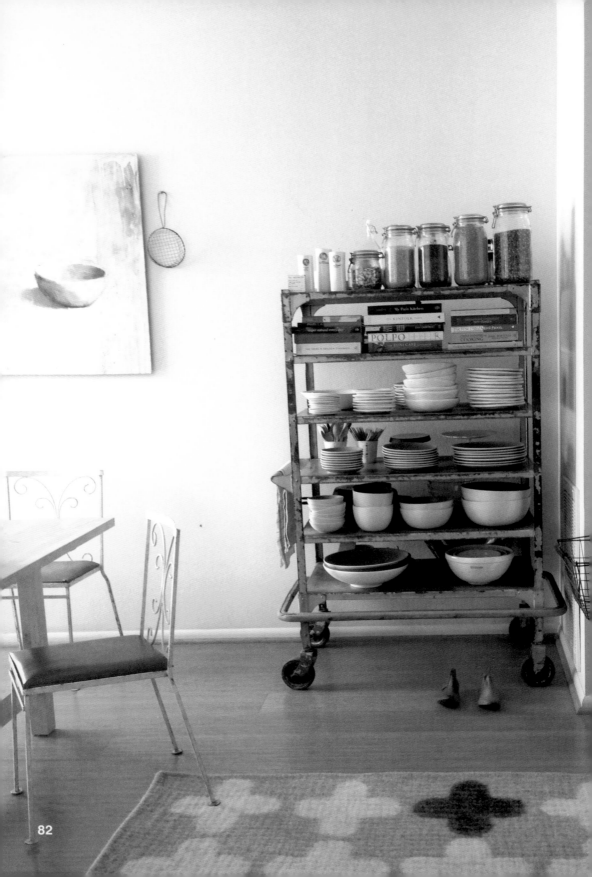

EVEN the MOST BASIC KITCHEN STAPLES
CAN ADD BEAUTY TO YOUR HOME...

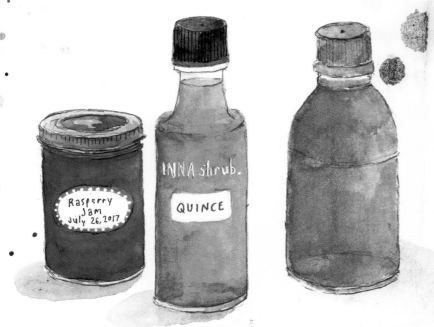

Rasperry
Jam
July 26, 2017

INNA shrub.

QUINCE

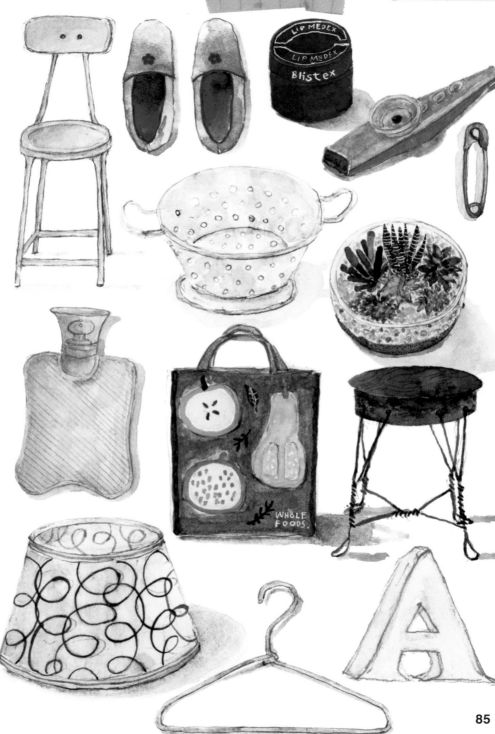

GooD oN PaPeR.

Paper is one of man's finest inventions. Without it, we wouldn't
have books, letters, documents, packaging, money, or toilet paper!
I collect all types of paper and ephemera. There is something
about the tactile nature of paper that makes it very desirable. In
this digital world, for me, writing on paper is a more cerebral
and emotional way to keep track of things, process thoughts, and
work out new ideas. Vintage paper, like handwritten sheet music,
postcards, or Japanese scrolls, inspire new ways to compose
artwork—collage, writing vertically, embracing ink splatters, and
so on. I have volumes of journals and sketchbooks that I fill with
my deepest thoughts and where I sketch moments in time. Paper
is my friend, my constant companion. It is a blank slate that doesn't
require electricity or batteries. Paper waits for me.

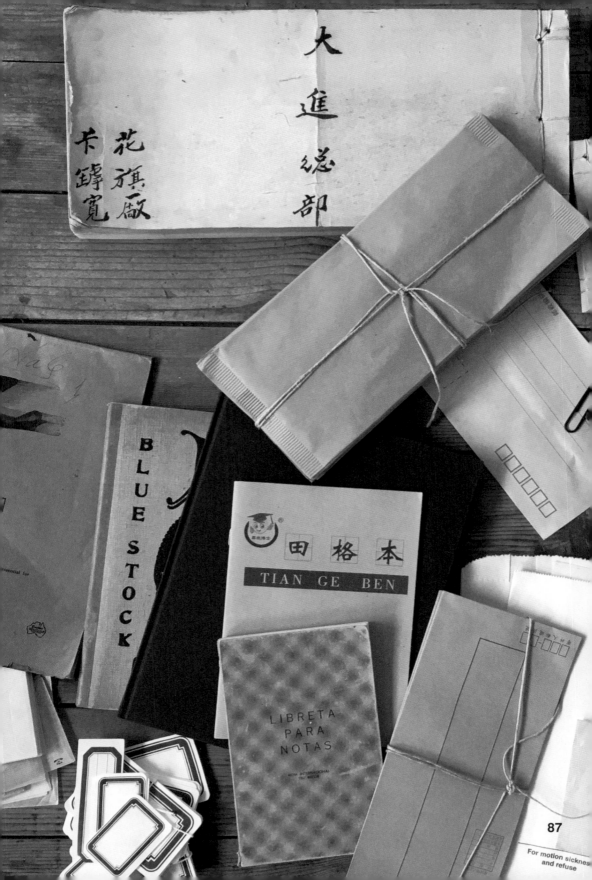

For motion sickness
and refuse

453204 No. 字

外交部

姓名 張氏
年歲 五十九
職業 主婦
籍貫 廣東南海
身量 五尺二寸
特徵

字第 541 號

Consul General of the Republic of China

21

Roy Dus

113634
DOLCE

Many people are seeking
you for your sound advice
02 12 24 32 42 2

オテフ
TEGAMISH

D. LAZZARONI & C.

SPECIALITA ITALIANA
AMARETTI ORIGINALI

BLUE
COOKIES

HUM

Mr. Mrs. Tr...
Trenton,
Mich.—

B. R. #1

UNITED AIR LINES
306-548
FLIGHT 382
TO
SFO
SAN FRANCISCO

WEIGHT
10
ADVANCE CHECK-IN

Mr and

announce

on Friday, the

Nineteen hu...

Fresn...

ELLE AIME LA MUSIQUE ELLE

FAT
FRESNO, CALIFORNIA

Fat 53:26-71

809-990

www.douglasparking.com

45087

SAVINGS ACCOUNT

No. 1713
Hanford #18 BRANCH
Bank of Italy
416 Street

DATE	AMOUNT	Teller	WITHDRAWN	DEPOSITED	BALANCE
OCT 30 '26	Dep			100=	100=
				67	10067
				200	10267
JUL 28 '29	Dep			300	40267
1 B APR - 6 '28				784	40971
				30000	70971
				919	71890
JUL 1 7 '28				100=	81890
				1602	83492
				1669	85161
				14839	100000
				1948	101948
				2038	103986
JUL 1 7 1930 Forward.				6014	110000

005606

89

ROLe OF PAPER.

FROM TODAY

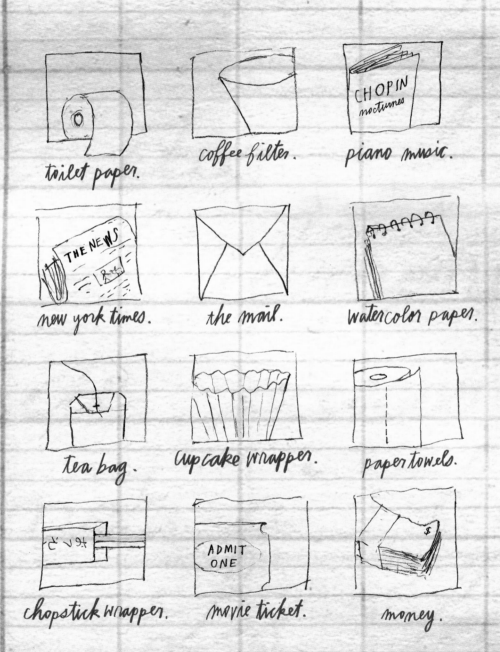

toilet paper.

coffee filter.

piano music. (CHOPIN nocturnes)

new york times. (THE NEWS)

the mail.

watercolor paper.

tea bag.

cupcake wrapper.

paper towels.

chopstick wrapper.

movie ticket. (ADMIT ONE)

money.

iN CoLoR.

I'm naturally drawn to earthy, muddy colors. These colors show up in my work again and again. To vary my palette, I like to observe unintentional color combinations in the world around me. Sometimes I see random objects next to other objects or things in front of a background where the color combinations are delightful and unexpected. I record these colors in a sketchbook by painting little squares of watercolor. I also record swatches of color throughout my day, the dress I'm wearing, my coffee, a door, the sky, etc. Doing this creates a library of color palettes with combinations that I never would have thought of myself.

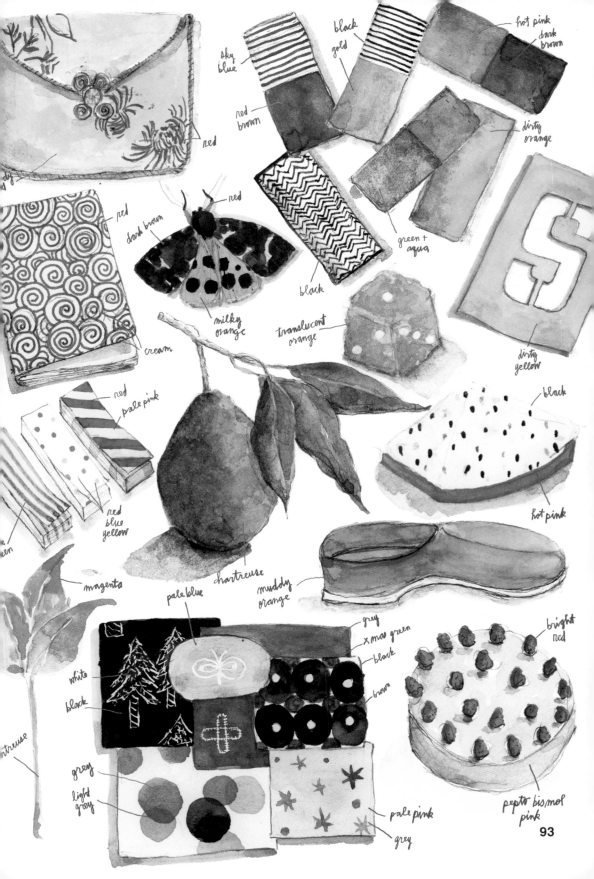

red

sky blue

black
gold

hot pink
dark brown

red brown

dirty orange

red

dark brown

red

green + aqua

black

dirty yellow

milky orange

translucent orange

red

cream

black

red
pale pink

red
blue
yellow

hot pink

magenta

chartreuse

muddy orange

pale blue

grey
xmas green
black

brown

bright red

white

black

chartreuse

grey

light grey

pale pink

grey

pepto bismol pink

93

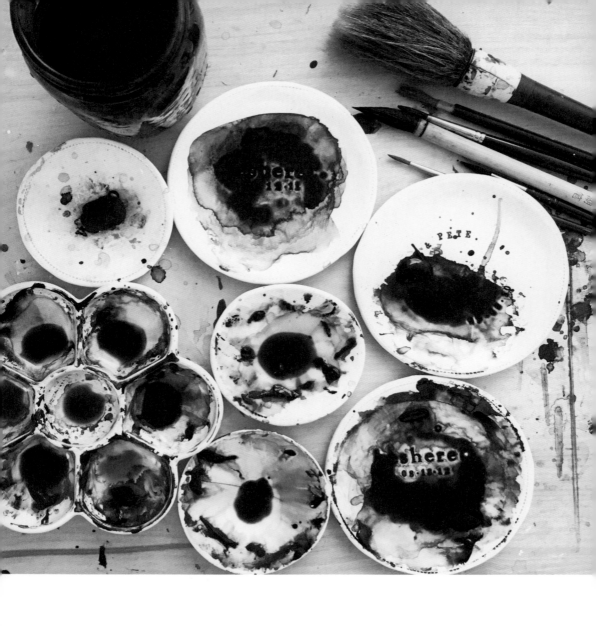

sailor blue.

poolwater.

indigo.

peacock
blue.

smokey
brown.

brick red.

lilac. hubba bubba. marine blue. pale gold. fern green.

NOV 1 2 2017

 pajamas.

new york times bag.

 ch

soft boiled eggs.

dog park.

f

OCT 0 5 2017

 wilma.

avocado.

the sky.

 schmincke water colors.

 grapefruit shrub.

cabernet.

MY DAY iN CoLouR.

NOV 2 4 2017

cabernet.

turkey.

yams.

 alad.

 NNeR.

SEP 1 4 2017

latte.

apron.

jeans.

 the bay.

 house slippers.

 salmon sashimi.

PARTS oF MY dAY.

RaNGe oF SieNNa iN SieNa.

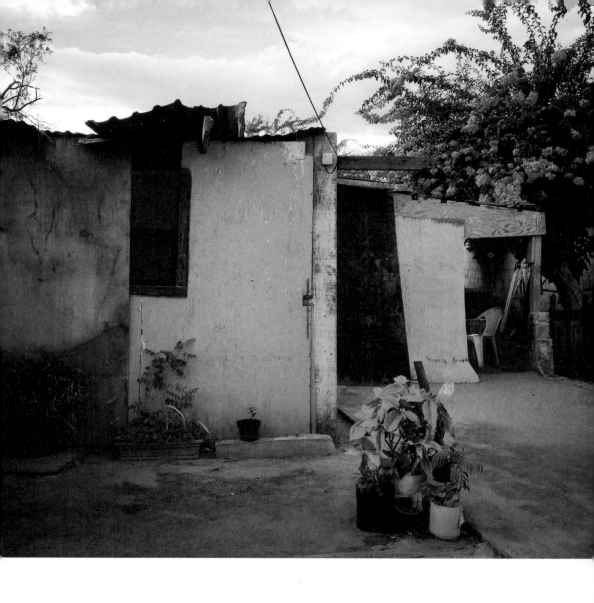

terra cotta.

wall.

wall.

bougainvillea.

sky.

window.

leaves.

dirt.

MY MuSe.

I am continually motivated by my dog, Wilma. She is my muse. Not only am I inspired by her iconic giant black spots, but also her demeanor, her mannerisms, her posture, and her humor. I watch how she moves through the world. I photograph her, I try to capture her in motion, and I draw her from memory. I admire her simplicity, the way she observes, her curiosity, her reactions. Drawing her honors her and will keep her spirit alive. Who or what is your muse?

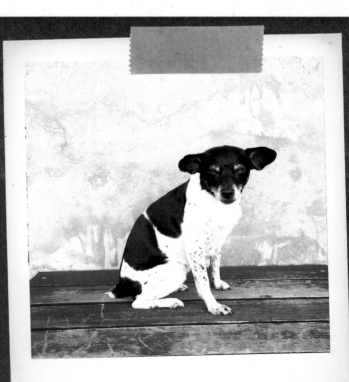

this is wilma.

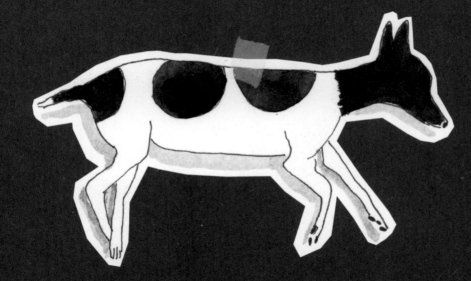

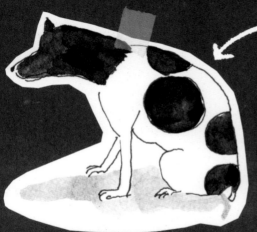

SHE HAS THE SAME POSTURE TODAY AS SHE DID WHEN SHE WAS 7 WEEKS OLD.

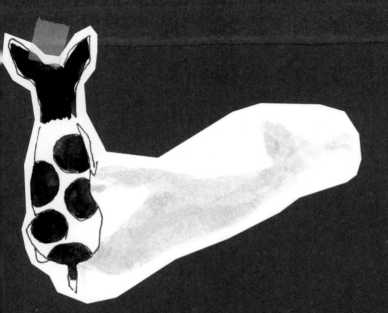

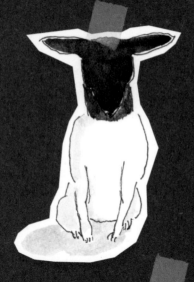

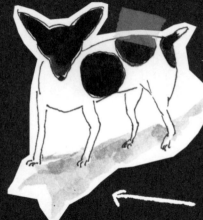

SHE HAS
TEENY
TINY
FEET.

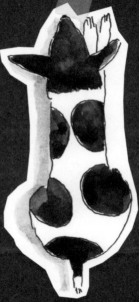

I LOVE HER
ICONIC GIANT
BLACK POLKA
DOTS.

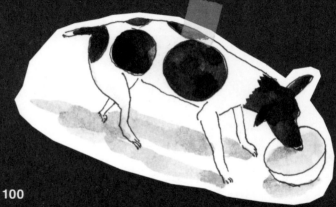

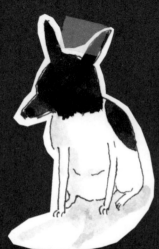

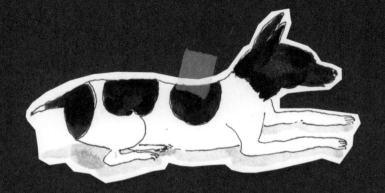

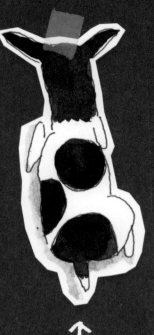

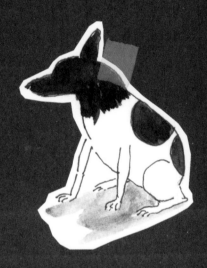

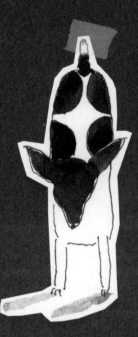

HER TAIL IS
LIKE A
PAINTBRUSH.

SHE HAS THE MOST
EXPRESSIVE EARS!

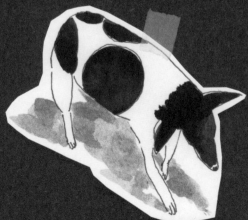

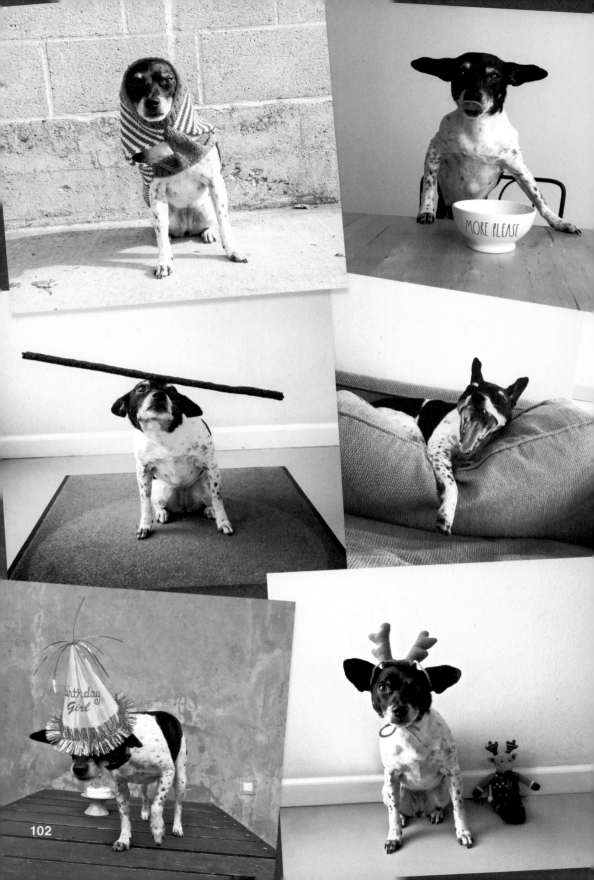

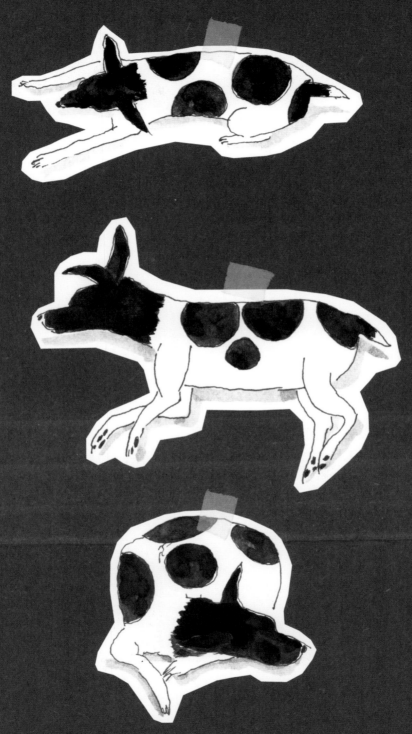

DOING WHAT SHE DOES BEST.

Let's tRaVeL.

There is so much out there in the world to see. That's why travel is so important to me. I love going to new places, seeing new things, and experiencing different cultures. Fortunately, travel does not always require a passport! Even going to a new street or neighborhood can be inspiring. I love seeing something so compelling, so fascinating, so intriguing, that I am actually taken aback by it. For souvenirs, I bring back things from the place itself: sand from the beach, water from the ocean, sea glass, packaging, bottle caps, napkins, ticket stubs, even garbage scraps found on the street. I'm drawn to finding the authenticity of each place I visit and I love coming home with a little piece of everywhere I go.

dark brown.
latte.

taupe

dark red
brown

mustard
forest
bright
terra
cotta

flying into fez.

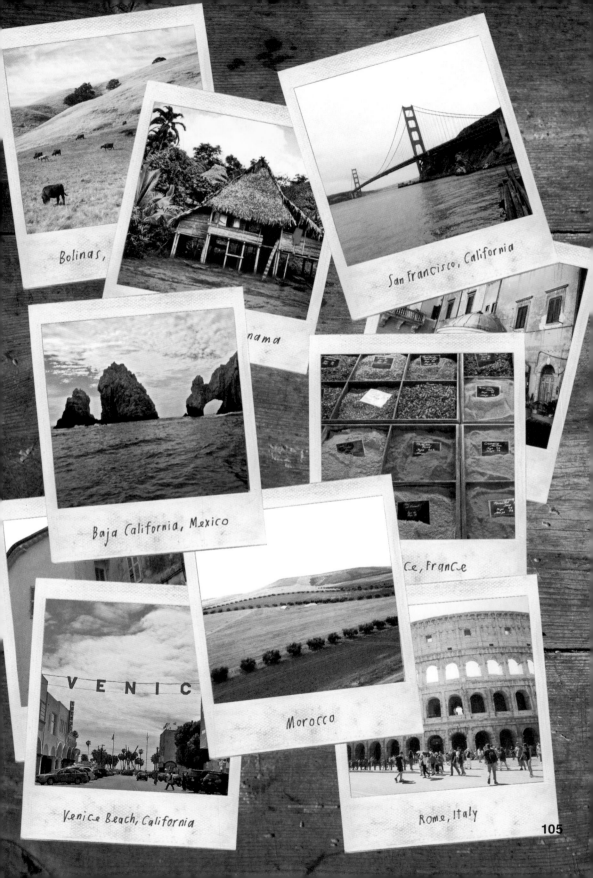

Bolinas,

San Francisco, California

nama

Baja California, Mexico

ce, France

V E N I C

Morocco

Venice Beach, California

Rome, Italy

There are so many choices of slippers in Marrakech... i chose these yellow ones.

a monkey tooth necklace in Panama

a sidewalk in Portofino.

zucchero di CANNA

a cute packet of Roman sugar.

i bought this hat in Sicily, but it was actually made in Africa.

chunks of indigo i brought back from Morocco. the color is so intense!

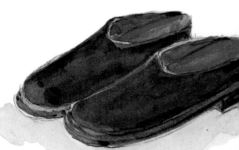

i adore these fabric covered buttons at Minä Perhonen.

these beautiful leather clogs in Japan. ¥3800

GUANYIN.
great compassion mantra.

FOR LUCK!

フラミスウ

MY FAVORITE BOTTLE
OF WATER IN JAPAN.

such a PRETTY
SOUP SPOON
IN TAIPEI.

a POUCH IN CHINA.

i BOUGHT tHIS
RING to
ReMINd me OF
tHE SuNSeTS IN
GReeCe.

tHIS BEAUtIFUL BORO BaG
WaS IN a tINY ShOP tHAT
We StuMBLed UPON DOWN
aN aLLey IN tokyo.

GiaNt RUStY SCISSORS at
tokyo FLea MaRket.

tHe CHeF GaVe Me tHeSe DiSHeS!

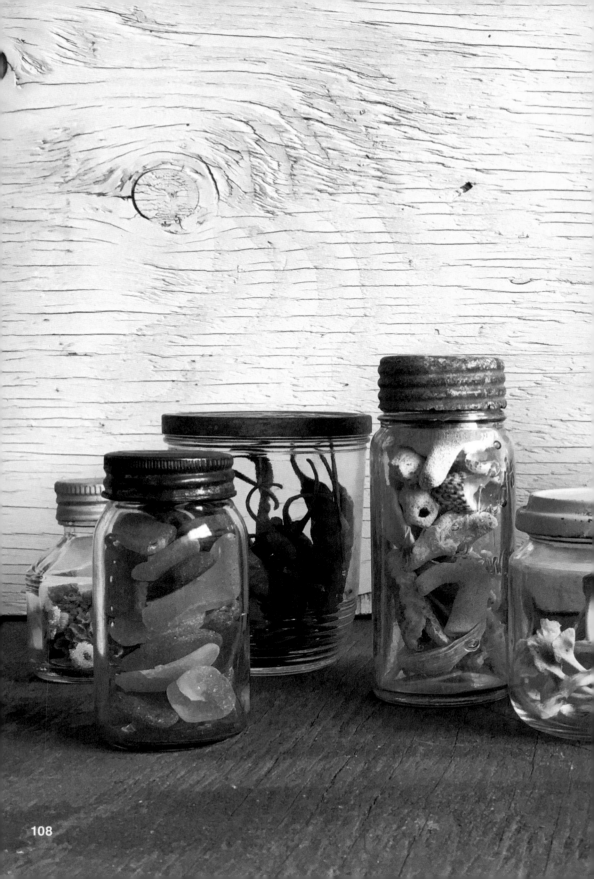

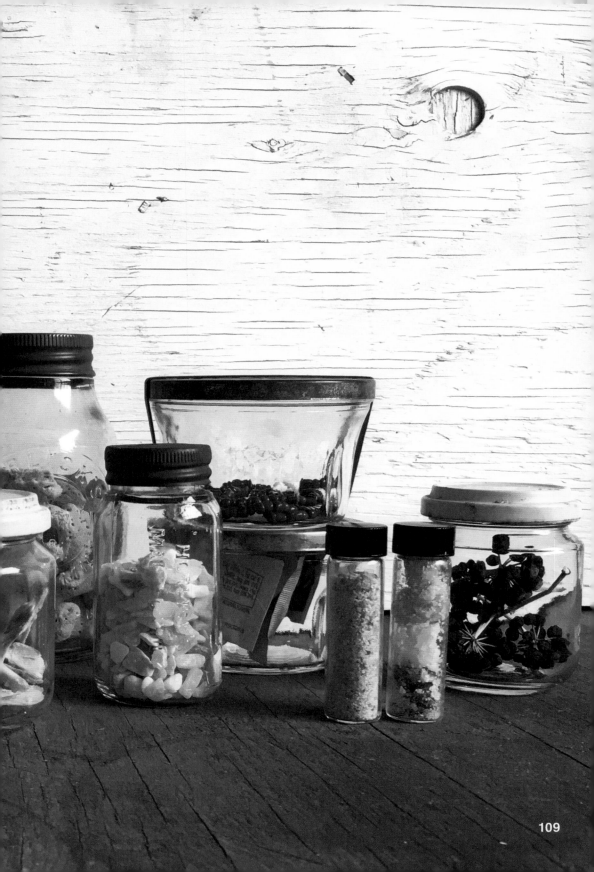

NOTES
<u> </u>

111

ACKNOWLEDGMENTS

Johnny Wow (always there), Wilma, Stephanie Perry (my left-handed right-hand girl), Bridget Watson Payne (she convinced me to write this book), Kate Woodrow, Connie and Roy Dunn, Corrie Dunn, Jackie Swoiskin, Rick Jow, Keay and Dave Wagner, Polly Wagner, Wm. Levine, Finn Olcott, Ivy Olcott, Nate Mondschein, Anmy Leuthold, Mickey Breitenstein, Micha Perks, Tamar Hurwitz-Fleming, Drew Fleming, Jessie Williams, Erin McGuiness, Emily Payne, Melissa Gomes, Erica Tanov, Eden Rodriguez, Leigh Wells, Lawrence Cowell, Maybelle Imasa-Stukuls, Linea-Carta, Angie Wotton, Stacey Bristol Lautenslager, Mandy Chew, Samantha Ho, Matt Leary and Mimi Richart, Mr. Digby, studio dot's, the monkey cage.

All of the photos in this book were taken with my iPhone 5.